VINCENT

Vincent
By Barbara Stok

TRANSLATION BY Laura Watkinson

WITHDRAWN

SELF MADE HERO

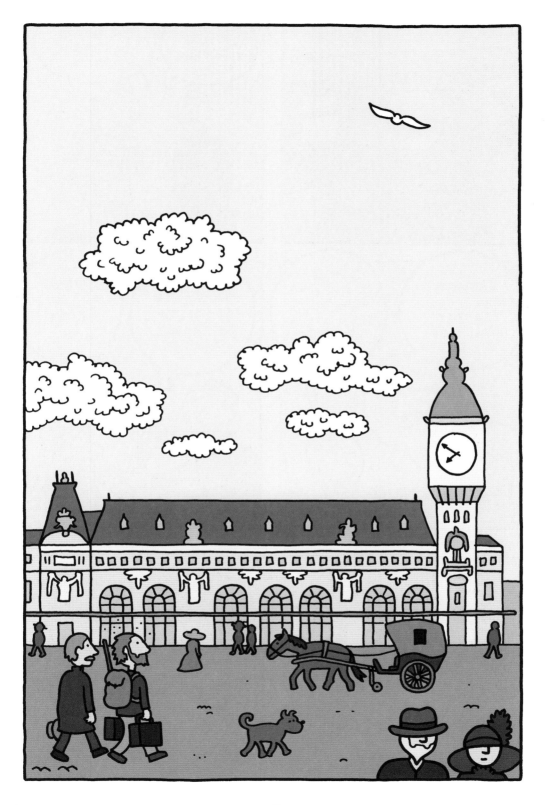

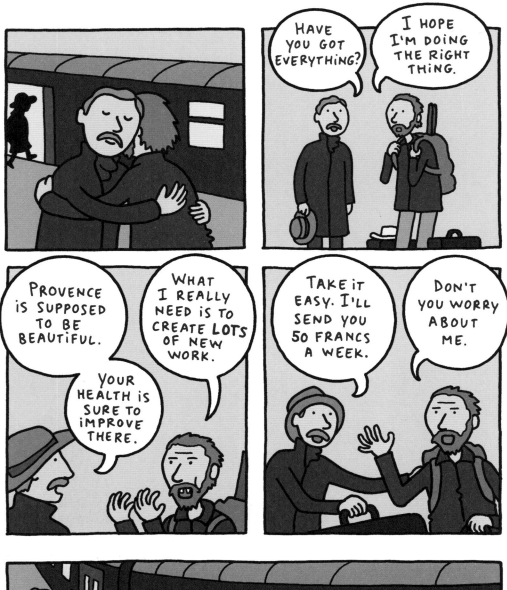

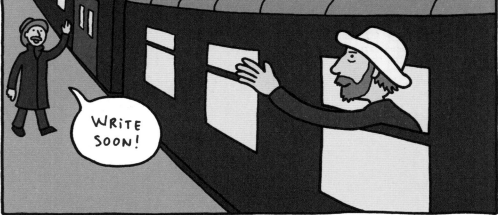

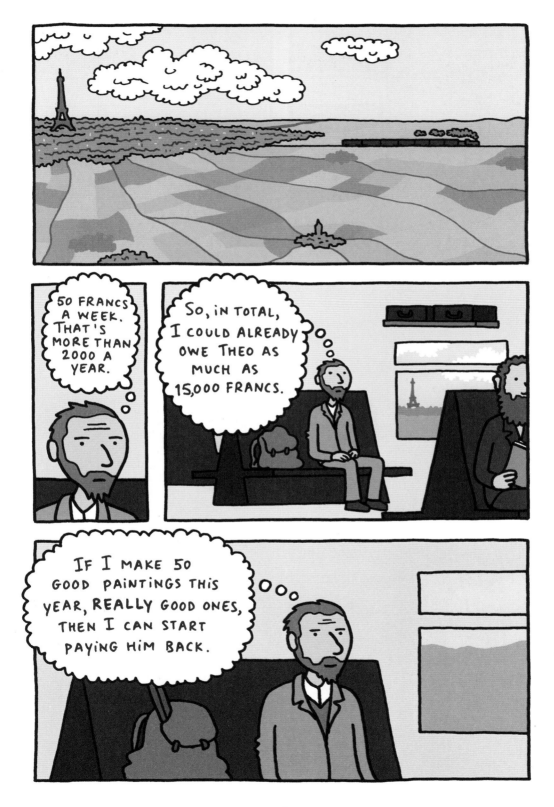

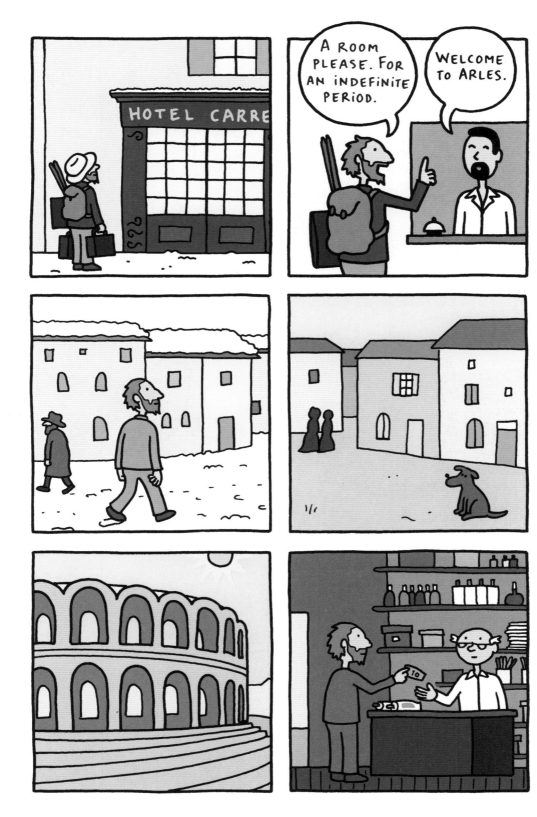

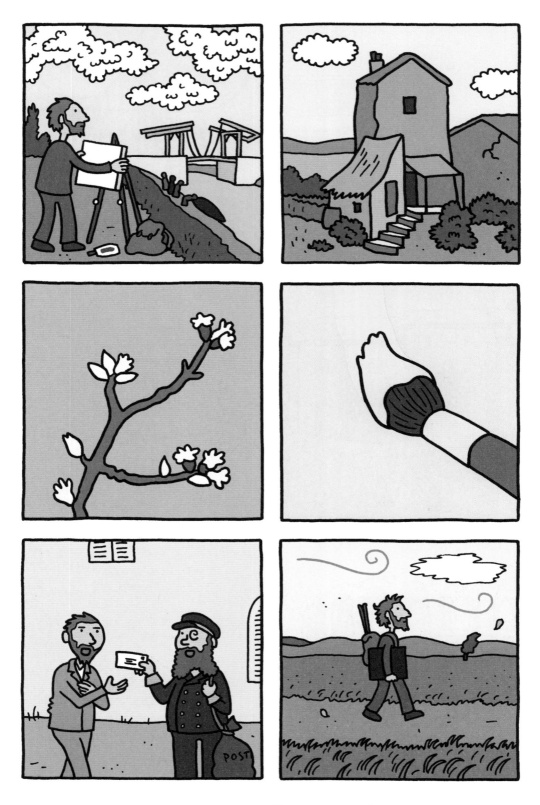

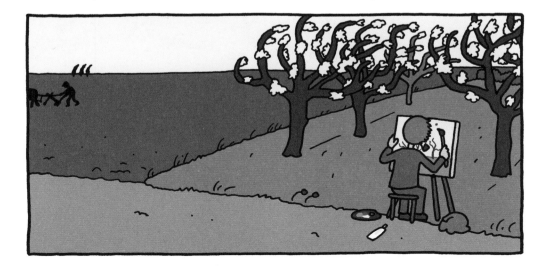

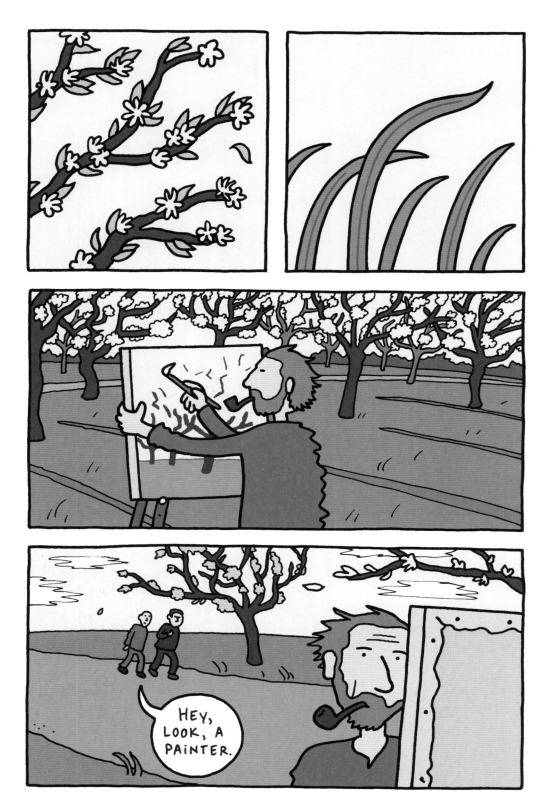

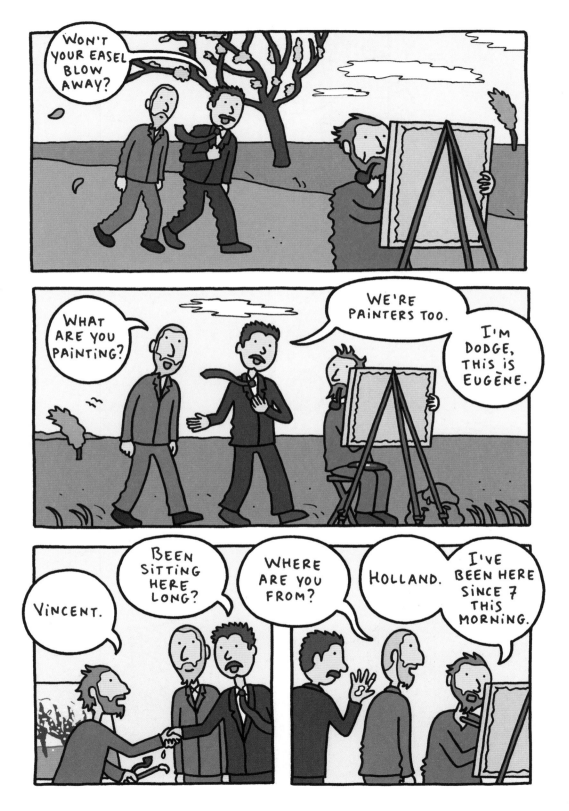

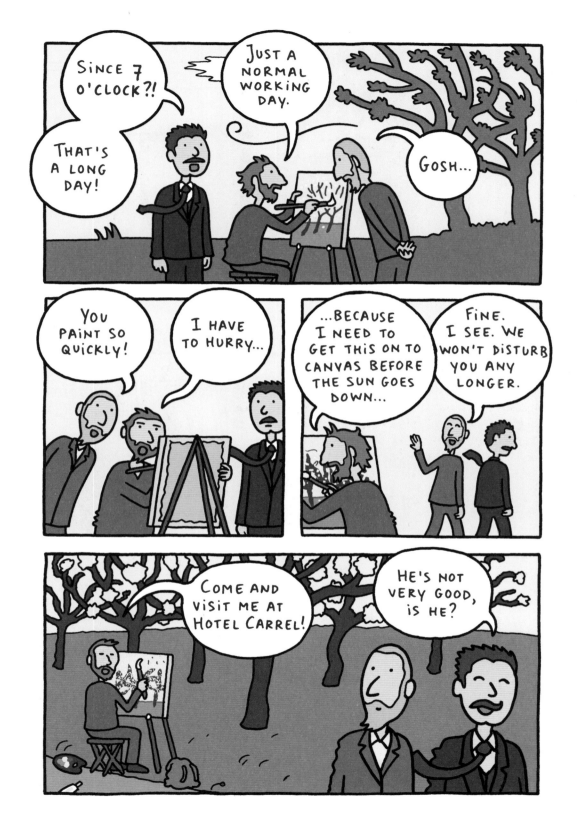

My DEAR THEO,

I AM DELIGHTED, DELIGHTED, DELIGHTED BY THE LOCAL LANDSCAPE. AT PRESENT I'M WORKING ON SOME YELLOW-WHITE PLUM TREES WITH THOUSANDS OF BLACK BRANCHES. WHEN I WAS PAINTING THIS MORNING, THE SUNSHINE MADE ALL THE WHITE FLOWERS SPARKLE. IT WAS SO BEAUTIFUL! THERE WAS A LOT OF YELLOW IN THE WHITE, WITH BLUE AND LILAC, AND THE SKY WAS WHITE AND BLUE.

I AM WORKING LIKE A MAN POSSESSED RIGHT NOW, BECAUSE I WANT TO PAINT AS MANY

ORCHARDS IN BLOSSOM AS I CAN. I AM WELL UNDER WAY AND I NEED TEN MORE, I THINK, OF THE SAME SUBJECT. PLEASE, FOR CHRIST'S SAKE, GET SOME NEW PAINT TO ME WITHOUT DELAY! THE SEASON OF ORCHARDS IN BLOSSOM IS SO SHORT.

I HOPE TO MAKE REAL PROGRESS THIS YEAR, AND I REALLY NEED TO DO SO. OUT OF FOUR CANVASES THERE MIGHT JUST BE ONE THAT WOULD MAKE AN ACTUAL...

...*PAINTING*, BUT I HOPE WE WILL BE ABLE TO EXCHANGE THE STUDIES WITH OTHER PAINTERS. DO YOU KNOW, DEAR BROTHER, I ALMOST FEEL AS THOUGH I AM IN JAPAN, BECAUSE OF THE CLEARNESS OF THE ATMOSPHERE AND THE BRIGHT COLOURS. IT IS JUST AS ONE SEES IN JAPANESE PRINTS.

I HAVE NO DOUBT THAT THE LONG JOURNEY TO THE SOUTH THAT I HAVE UNDERTAKEN WILL BE A SUCCESS.

THE AIR HERE IS DEFINITELY DOING ME GOOD. I WISH YOU COULD FILL YOUR LUNGS WITH IT TOO.

UNFORTUNATELY I HAVE HAD A TERRIBLY WEAK STOMACH SINCE ARRIVING HERE...

... BUT THAT'S PROBABLY JUST A MATTER OF TIME.

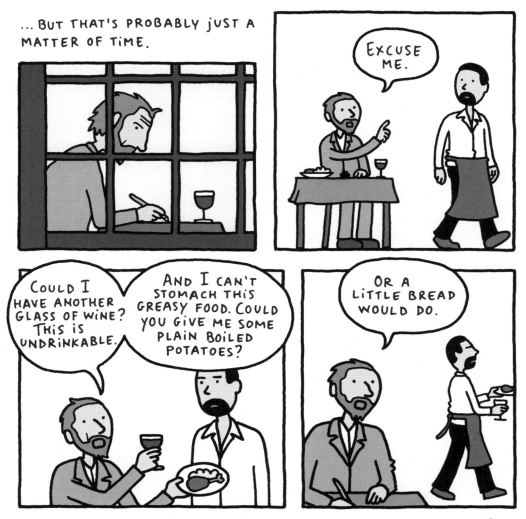

MY BLOOD IS RESTORING ITSELF – AND THAT IS THE MAIN THING. IN ANY CASE, I AM ALREADY MUCH BETTER THAN IN PARIS. FOR SO MANY REASONS, I WOULD LIKE TO CREATE A PIED-À-TERRE HERE TO PROVIDE A REST IN THE COUNTRY FOR POOR, EXHAUSTED PARIS CAB-HORSES LIKE YOURSELF AND SOME OF OUR FRIENDS, THOSE POOR IMPRESSIONISTS.

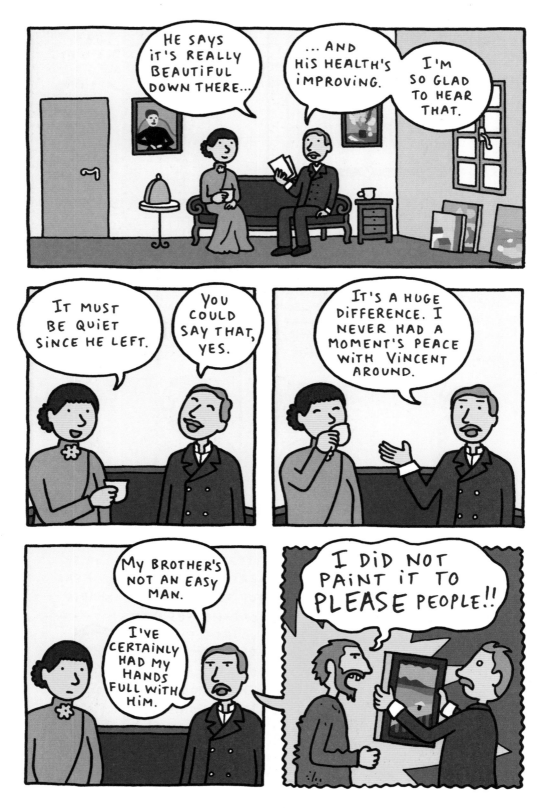

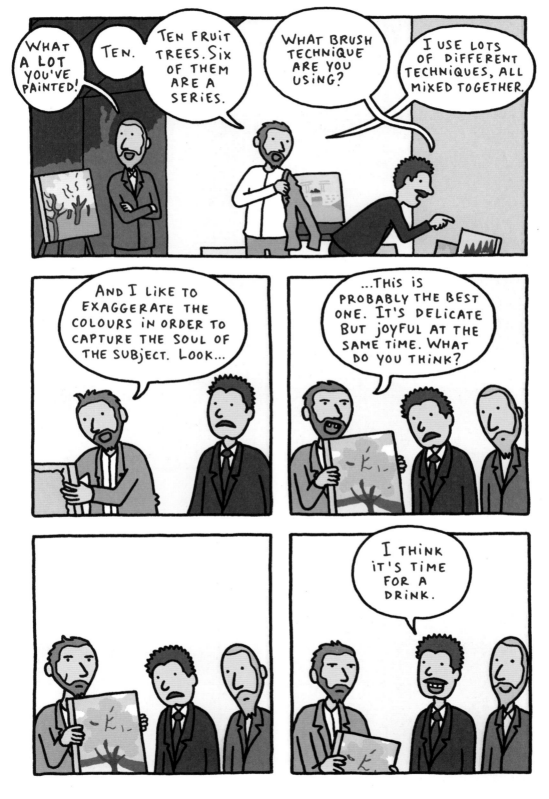

23

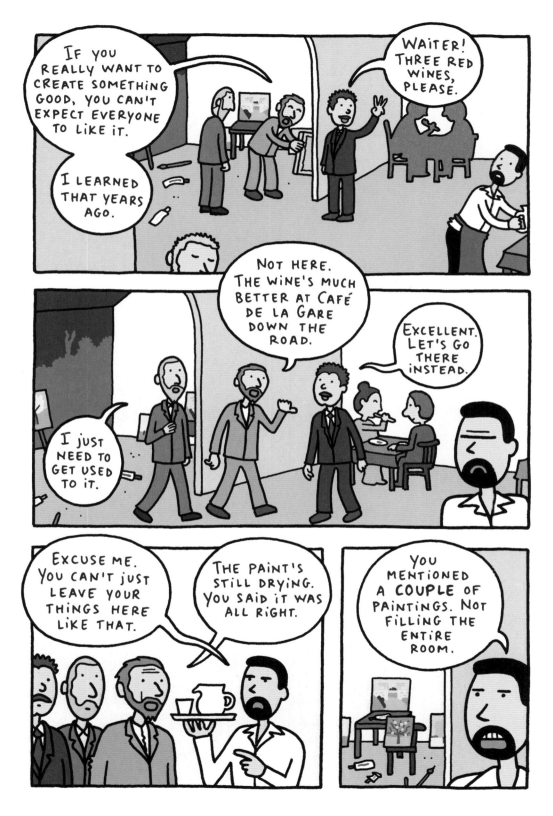

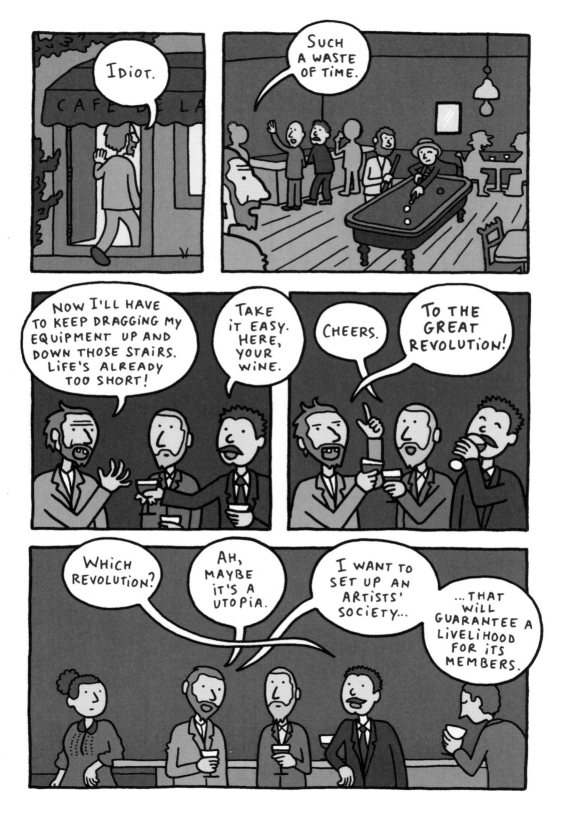

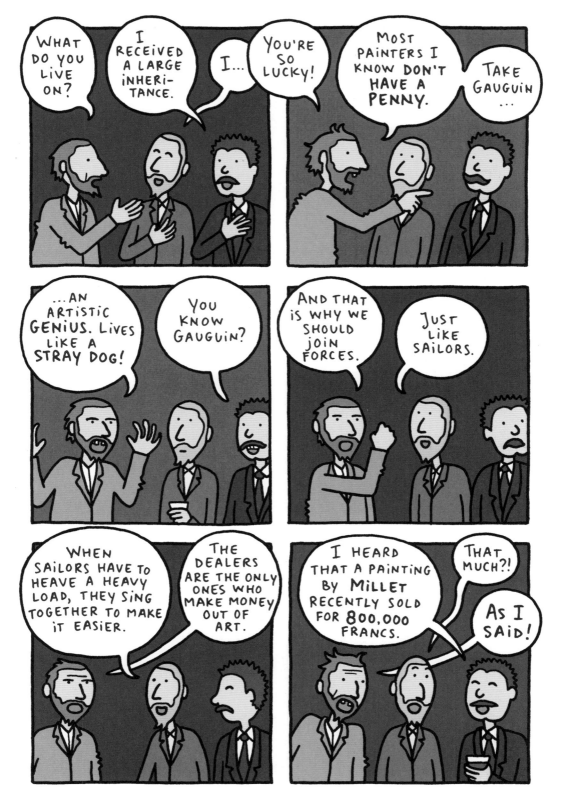

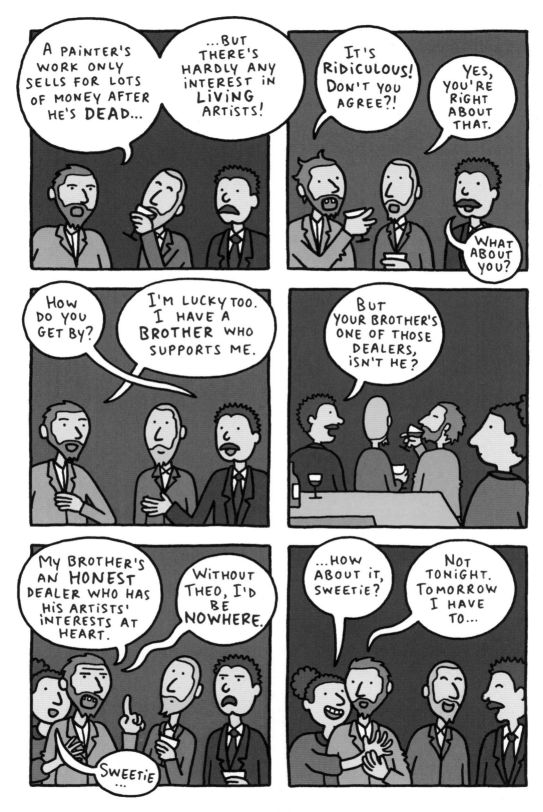

28

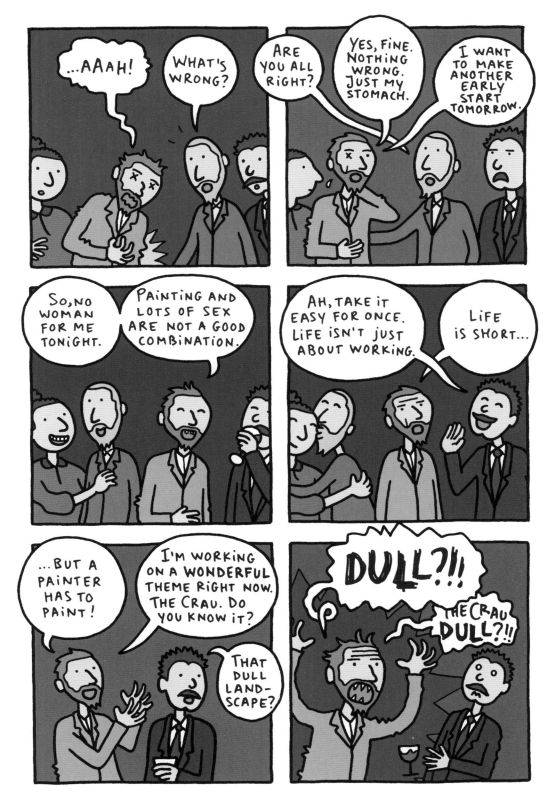

29

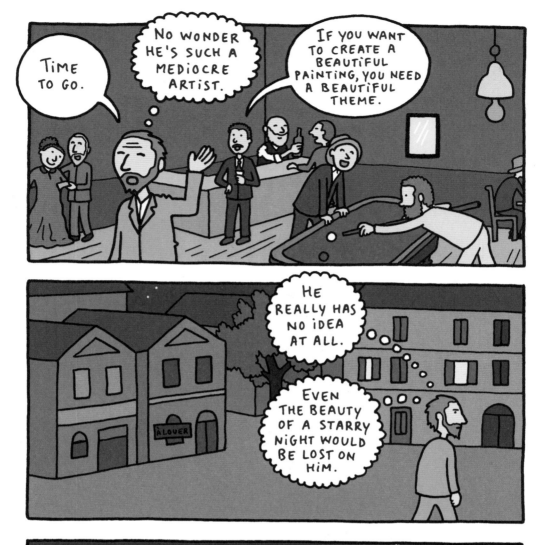

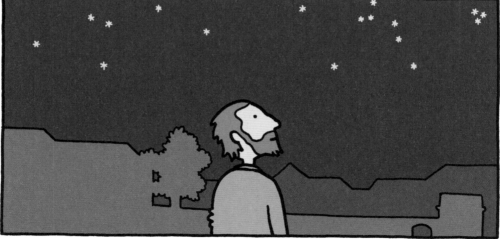

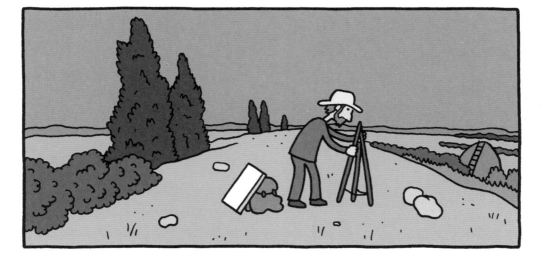

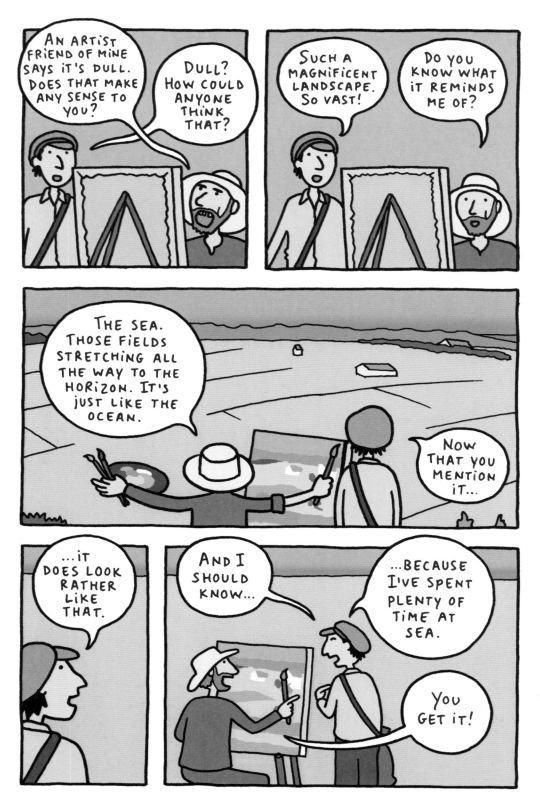

34

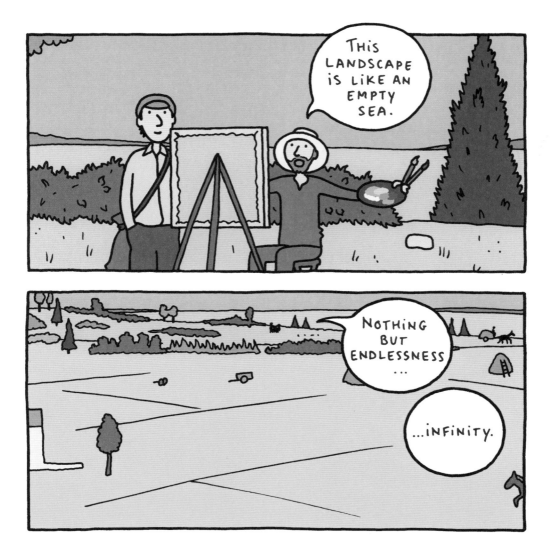

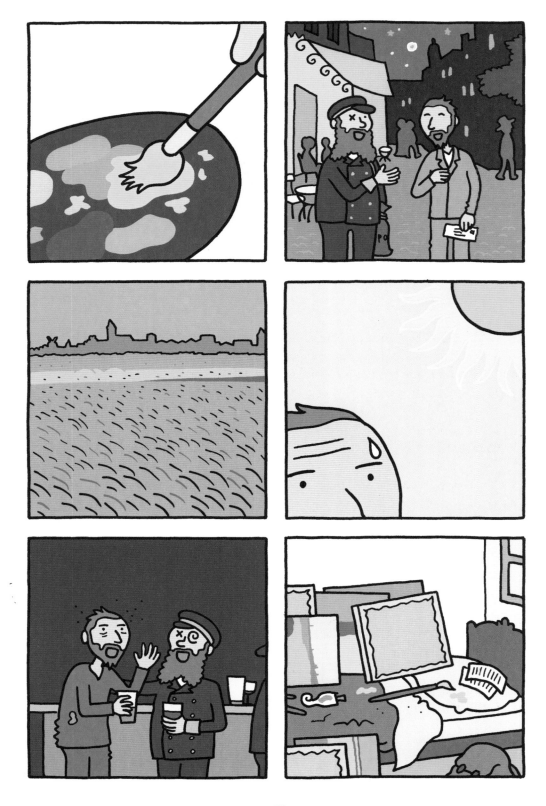

My dear Theo,

Ah, how I wish you could be here to see everything I am seeing. The morning in the fields has completely tired me out. The sun down here is so exhausting. It is quite different from in the spring, but I have no less love for nature now that it is starting to become scorched. There is old gold, bronze, copper in everything now and, with the green blue of the sky heated white-hot, that produces a delightful colour which is exceedingly harmonious, with broken tones à la Delacroix.

I have seven studies of wheat fields. The last one beats the others hollow. And now I have only just enough time to prepare myself for the new campaign, the vineyards. And I'd also like to do some seascapes.

I have masses of ideas for new paintings, but to my utter astonishment I am running out of funds again. I keep spending money without earning. It has already cost you, I imagine, around 15,000 francs, which you have advanced me over the years. I wish I were not such a burden on you. But I tell myself that if I manage to do 50 studies at 100 francs this year, then I shall breathe more freely. I do not yet have half that number ready to show to the public. I am already certain that people will criticise them for being rushed. We have to count on it taking years, perhaps, before Impressionist paintings have a firm value, but I strongly believe in a final victory.

I have to go now. I really am falling asleep.

VINCENT.

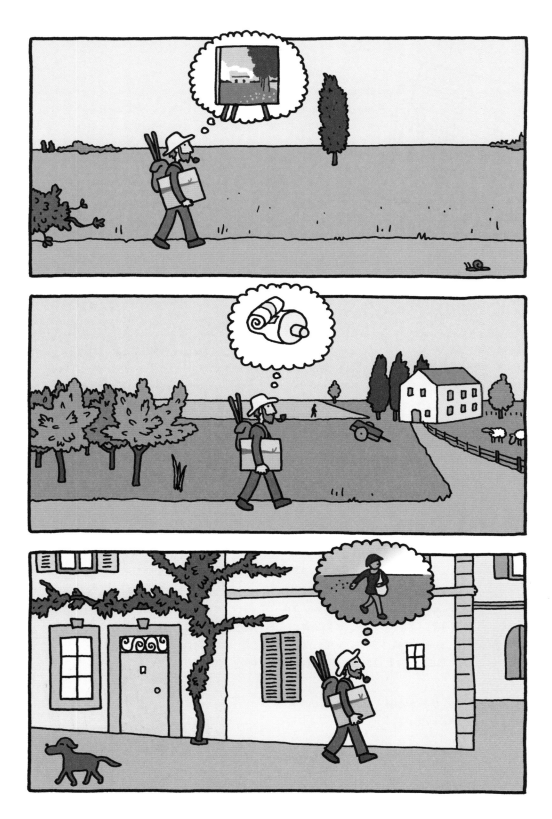

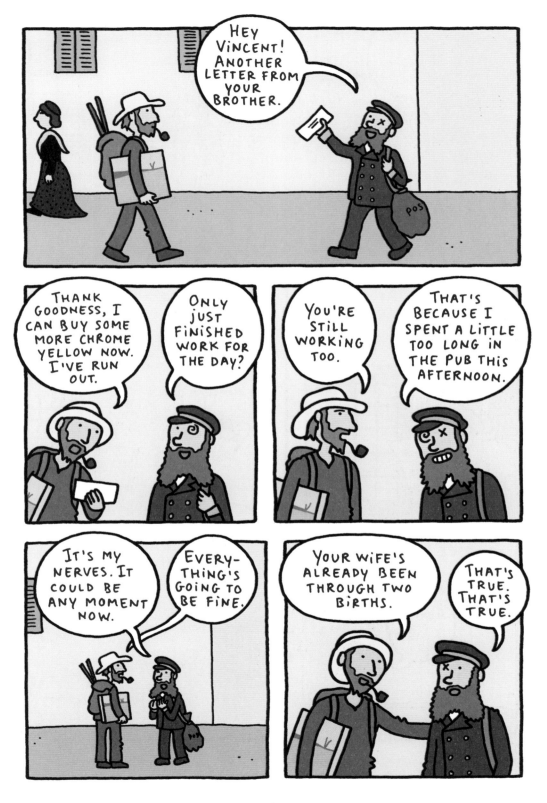

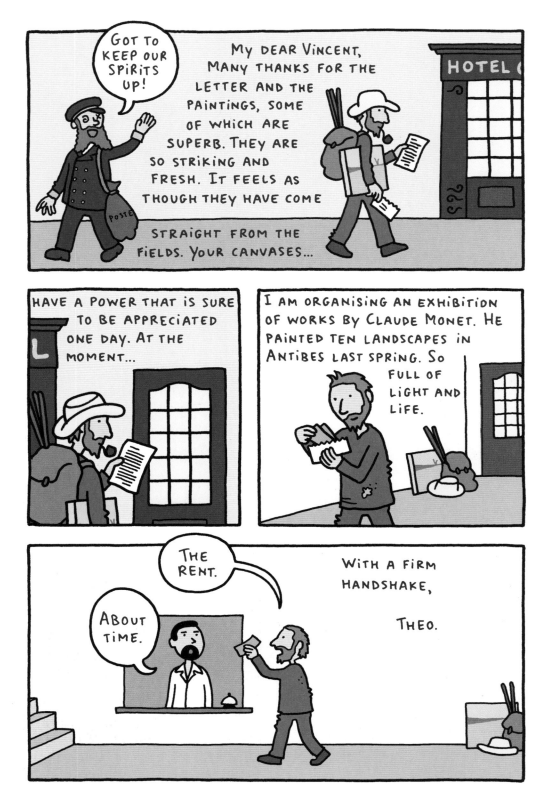

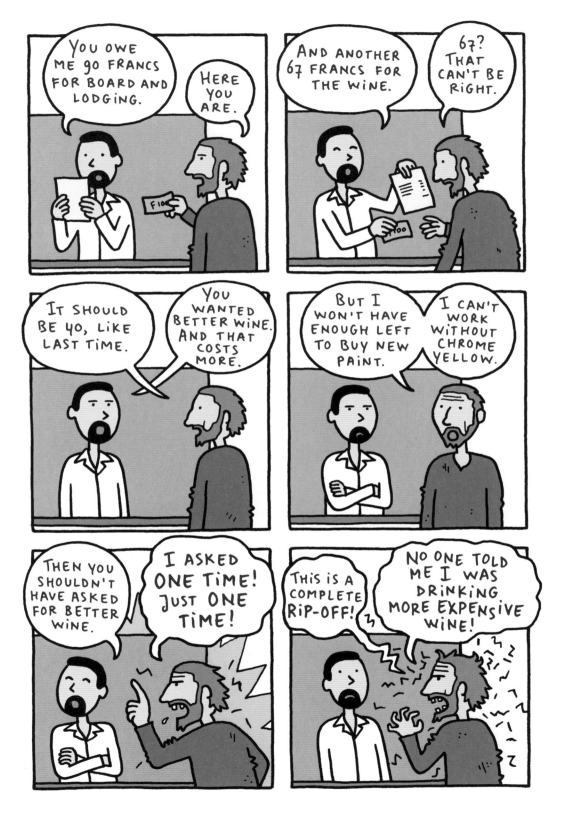

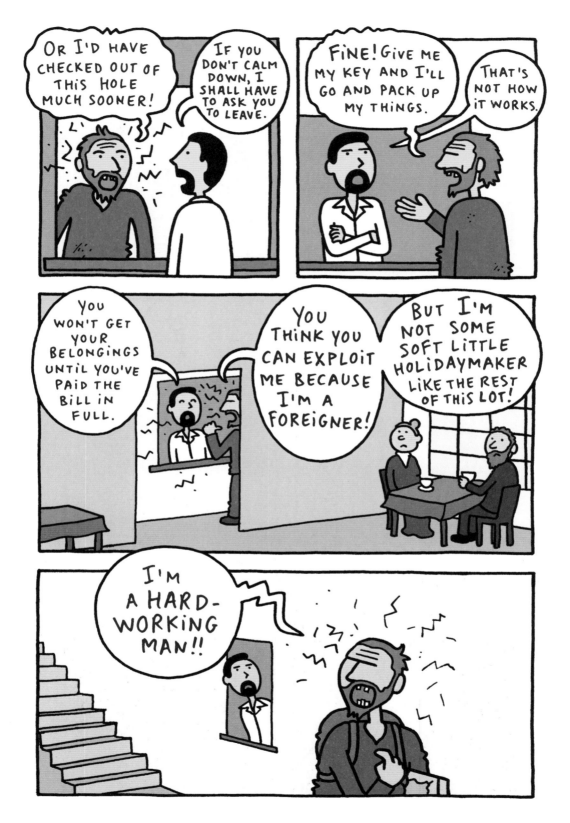

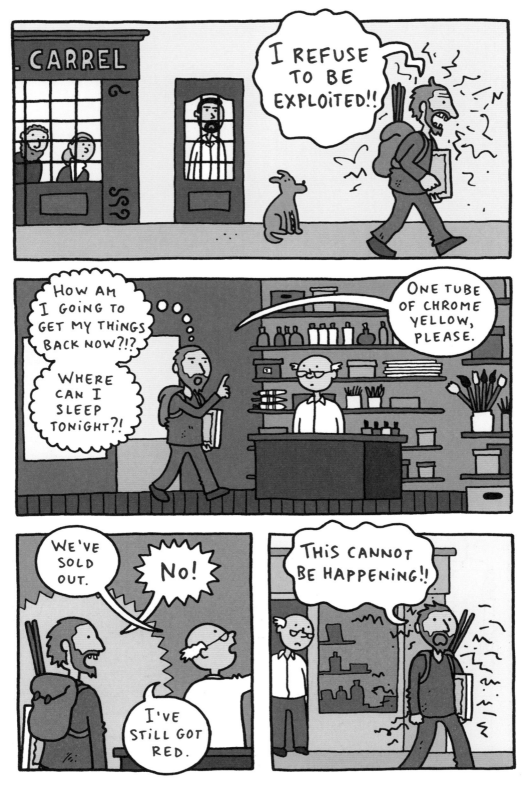

44

My dear Theo,
Since Tuesday I have been renting a house with four rooms. It is painted yellow outside, and it stands in the direct sunshine. I am paying 15 francs a month in rent. When I open the window in the morning, I see the green of the gardens opposite and the sun coming up. It is such a shame I did not find this house sooner. I hope to have more peace and quiet here for my work. I feel so much better now that I am free of that hotel.

I told those people that we would just have to go to the justice of the peace and explain. He suggested a settlement whereby I had to pay another 12 francs instead of 27, and the hotel owner received a reprimand for keeping my trunk.

IF IT IS NO TROUBLE, PLEASE SEND ME AN EXTRA 100 FRANCS AGAIN NEXT TIME, SO THAT I CAN BUY SOME MORE FURNITURE FOR THE HOUSE. I WANT TO BE IN A POSITION WHERE I AM ALWAYS ABLE TO PUT UP SOMEONE ELSE, SUCH AS GAUGUIN. I RECENTLY RECEIVED A LETTER FROM HIM IN WHICH HE SAID HE FELT CONDEMNED TO ETERNAL PENURY. I WROTE BACK AND INVITED HIM TO COME HERE. THE TWO OF US WILL BE ABLE TO LIVE IN THIS HOUSE ON THE SAME MONEY AS I SPEND ON MYSELF ALONE. GAUGUIN HAS SO MUCH TALENT THAT WORKING WITH HIM WOULD BE A STEP FORWARD FOR ME, AND IT WOULD GIVE YOU THE SATISFACTION OF SUPPORTING TWO ARTISTS INSTEAD OF ONE. LET US SEE IF HE ACCEPTS THE PROPOSAL.

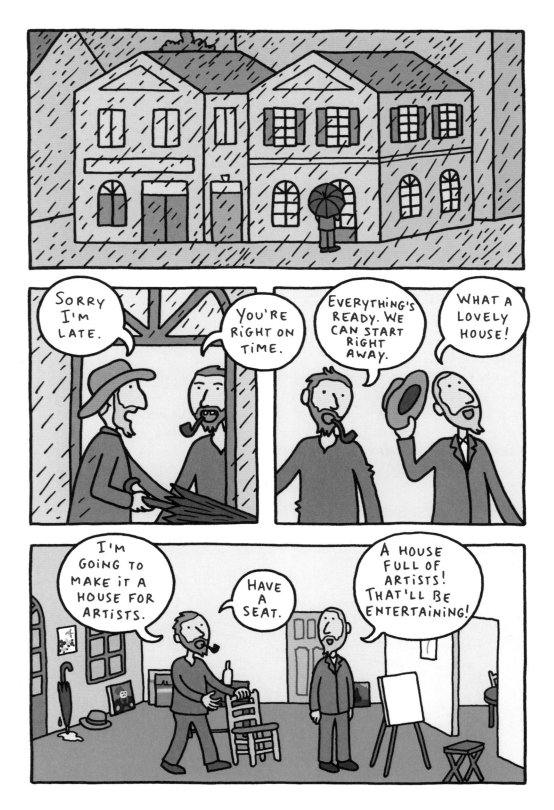

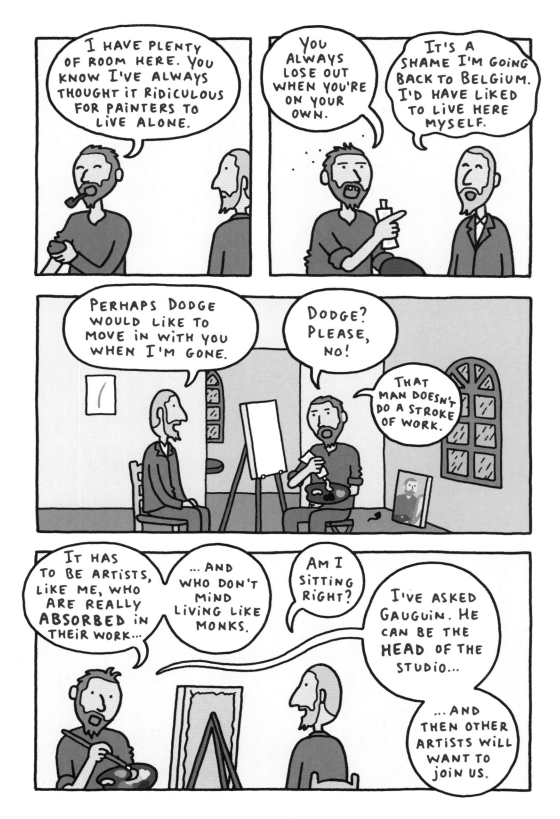

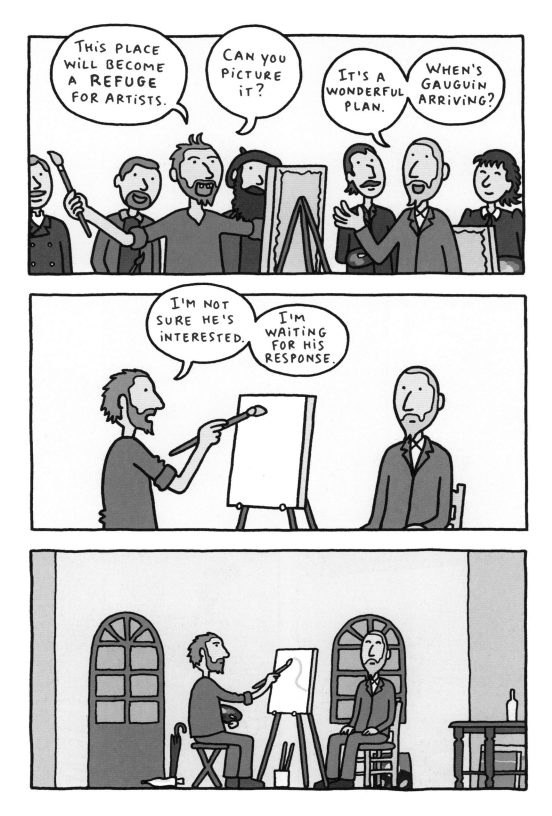

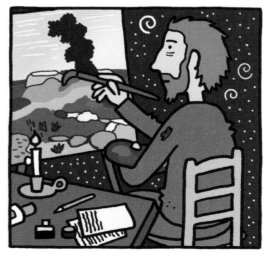

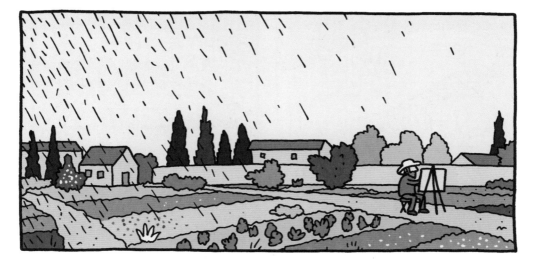

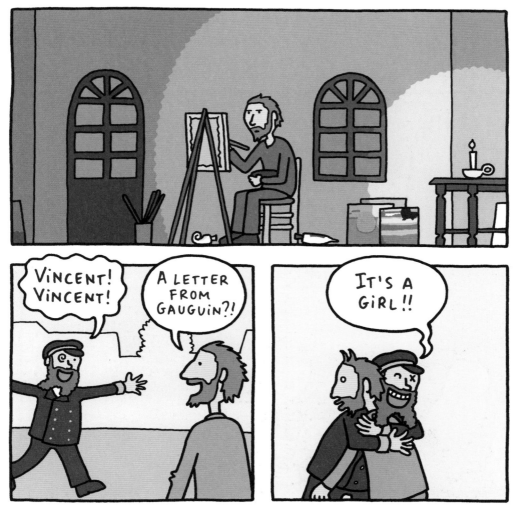

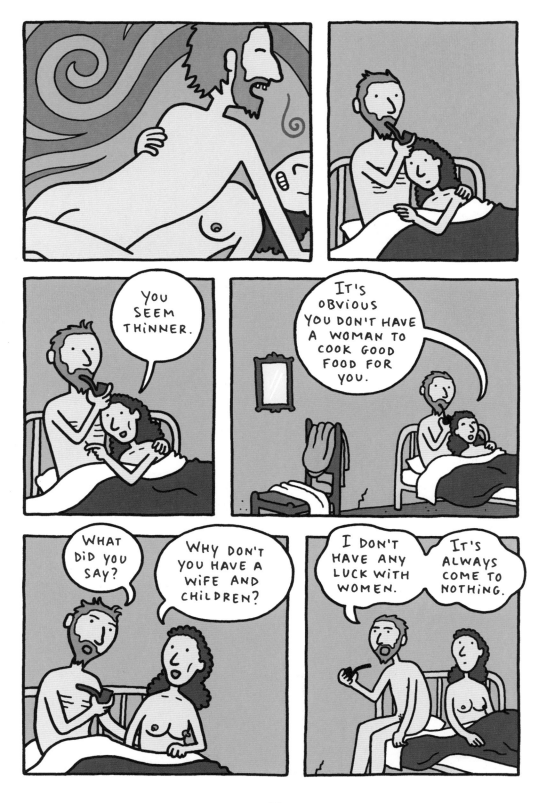

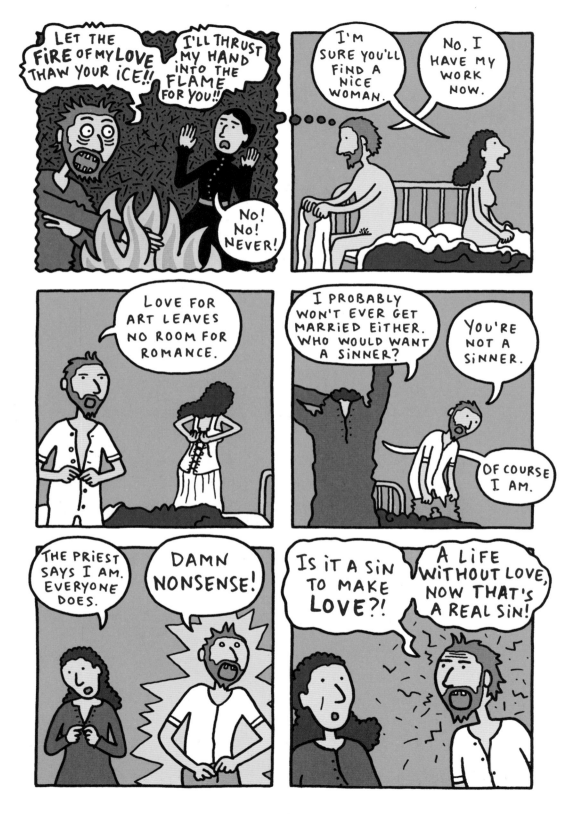

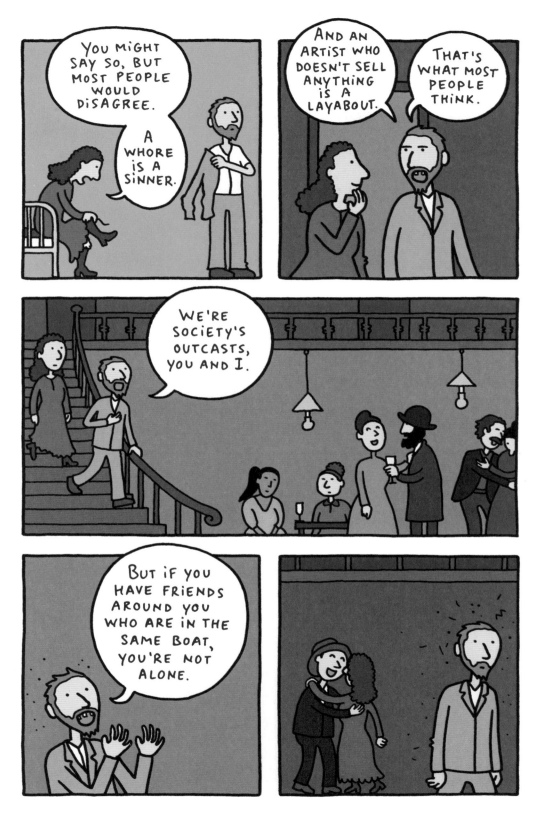

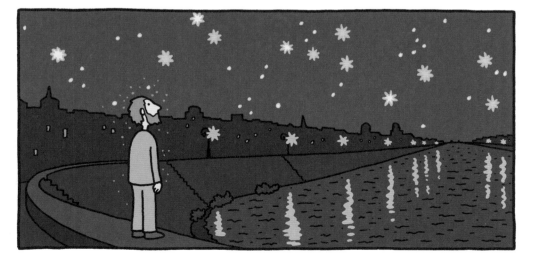

My dear Theo,
I have been thinking so much about you and about Gauguin and about Bernard, always and everywhere. I so wish that everyone were here.
I suspect you might like my latest painting, Starry Night. It often seems to me that the night is even more richly coloured than the day, with hues of the most intense violets, blues and greens.

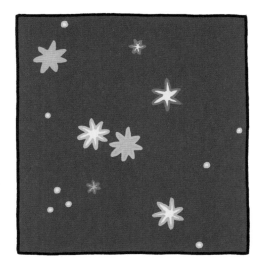

The sight of the stars always reminds me of the black dots on a map that represent towns and villages. Imagine that those spots of light in the firmament were as accessible to us as the black dots on the map of France. Just as we take the train to go to Tarascon or Rouen, we take death to reach a star. So it seems to me not impossible that cholera, consumption and cancer are celestial means of locomotion just as steamboats and trains are terrestrial ones.

In the life of the painter, death may perhaps not be the most difficult thing. My mind has been so dull for weeks. I need to take care of my nerves. When my emotions are in a state of agitation, I become more and more preoccupied with thoughts of eternity.

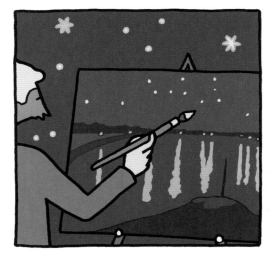

Have you heard from Gauguin? If he comes here it will open up a new era for us. My idea is that we will set up a house for artists that will remain in existence not only for our lifetimes, but which can be continued by subsequent generations when we are gone. If what you are doing offers a prospect of infinity, then your life has meaning after all.

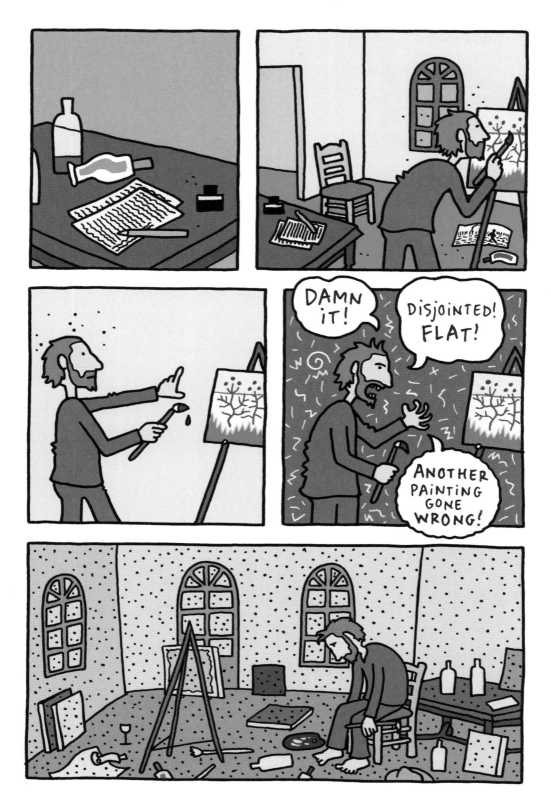

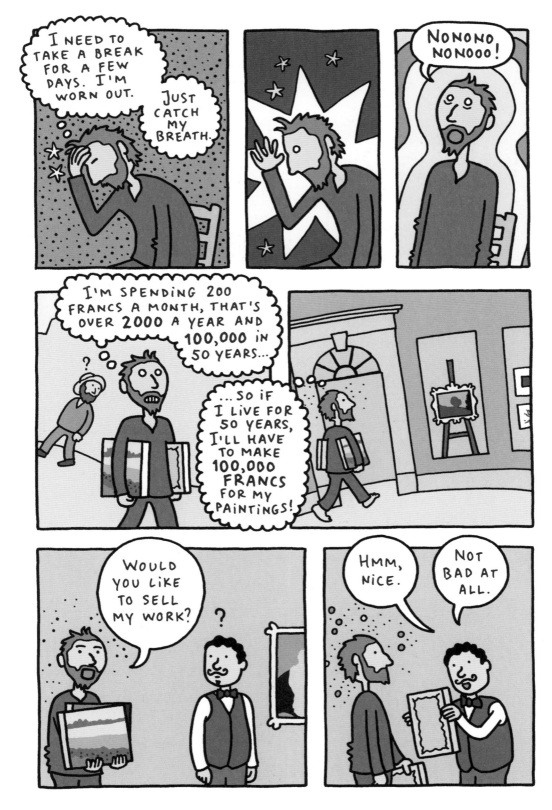

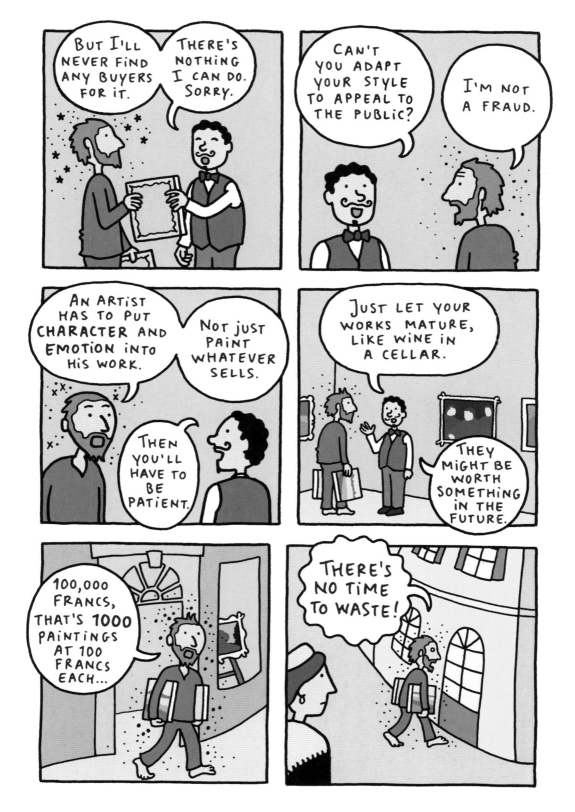

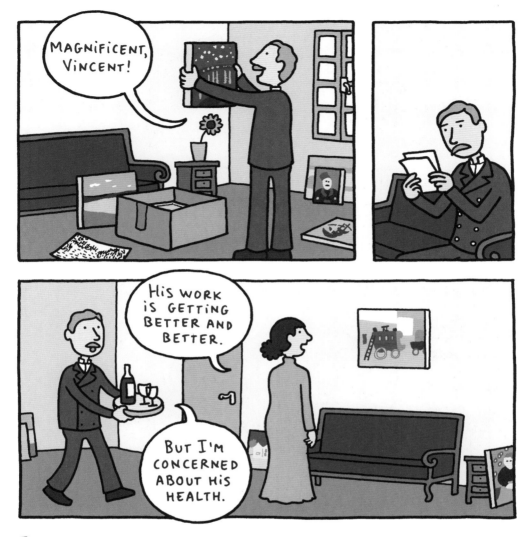

I SEE FROM YOUR LAST LETTER THAT YOU ARE WORRIED ABOUT A
LOT OF THINGS. I NEED TO SAY SOMETHING TO YOU ONCE AND FOR
ALL. YOU MENTIONED THE MONEY YOU OWE ME AND
SAID THAT YOU WOULD LIKE TO PAY ME BACK. I
WILL NOT HEAR OF IT. I ASK JUST ONE THING OF
YOU AND THAT IS THAT YOU SHOULD NOT WORRY
ABOUT ANYTHING. YOU CANNOT DO A THING
ABOUT YOUR PAINTINGS NOT SELLING. IT IS
BECAUSE THIS UNWORTHY SOCIETY IS ONLY
ON THE SIDE OF THOSE WHO HAVE
NO NEED OF IT. I REALLY HOPE
GAUGUIN WILL JOIN YOU SOON.
HIS COMPANY WILL DO YOU GOOD.

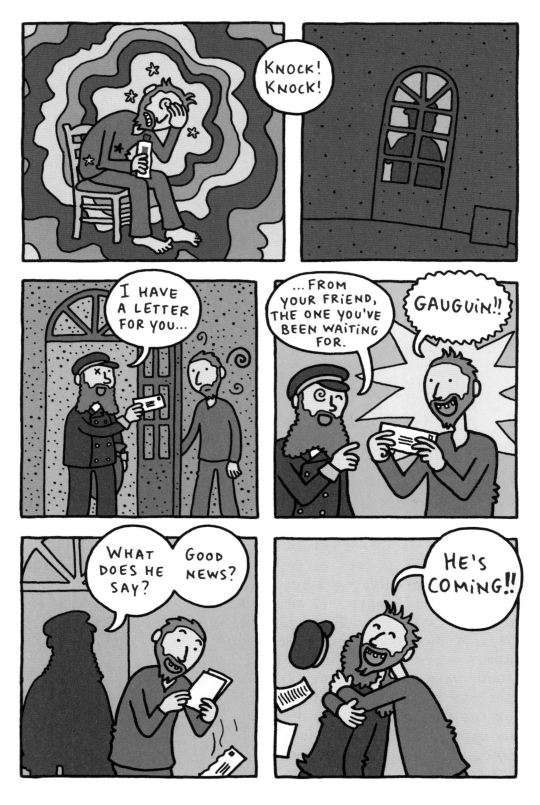

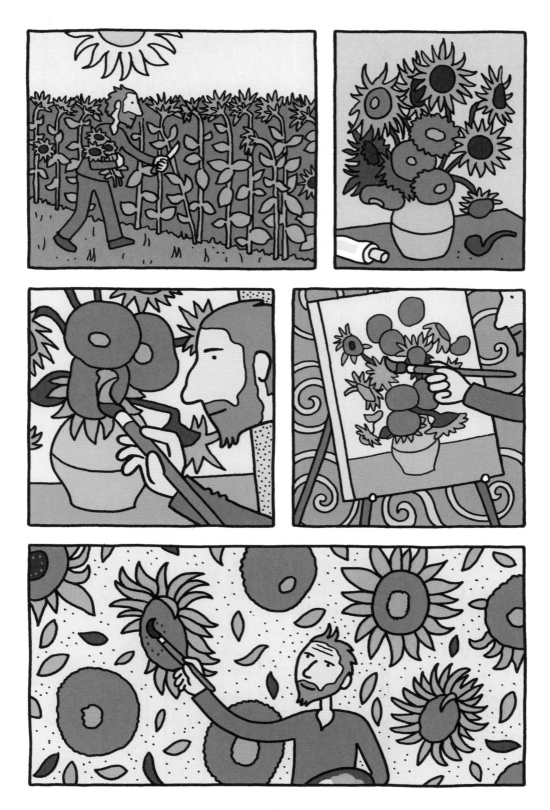

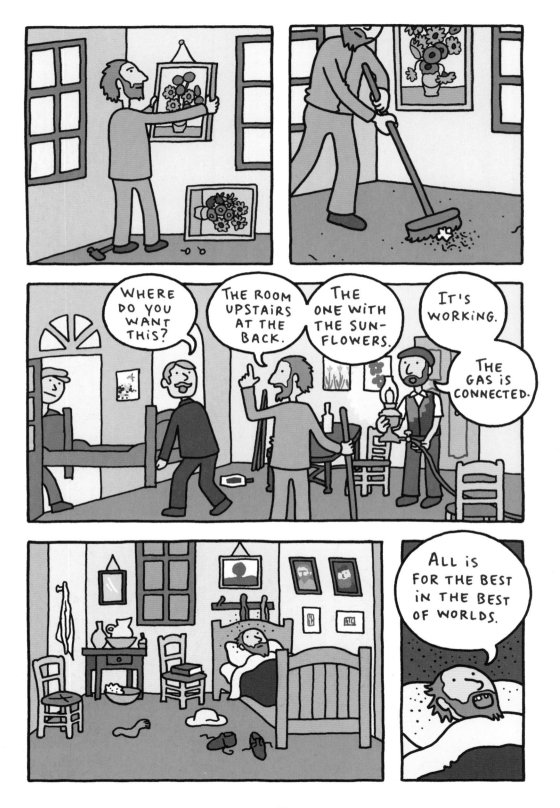

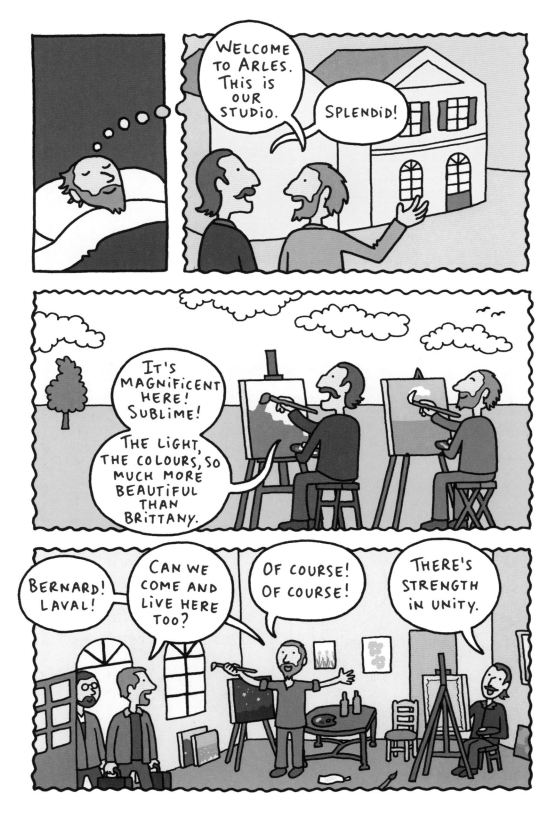

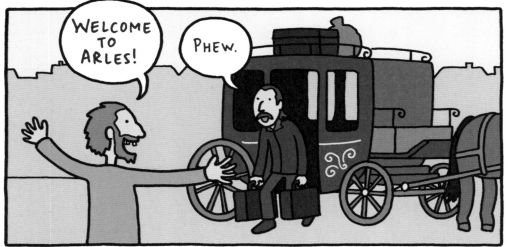

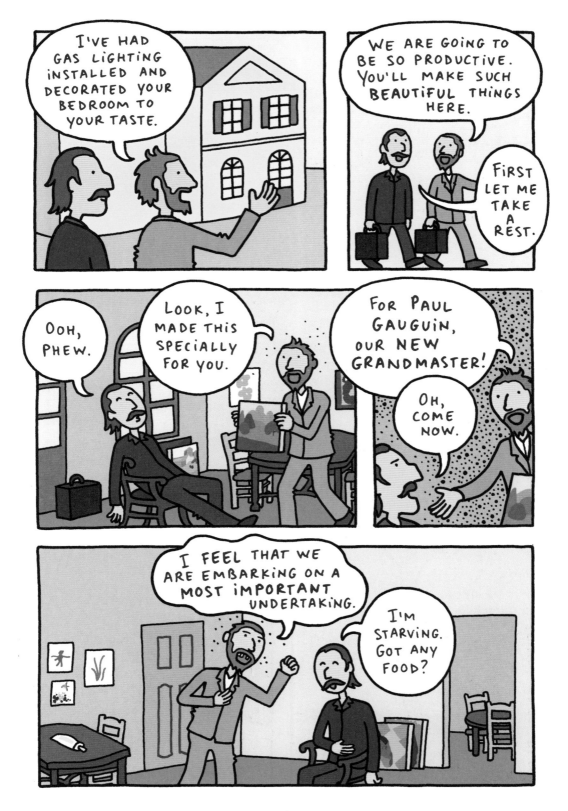

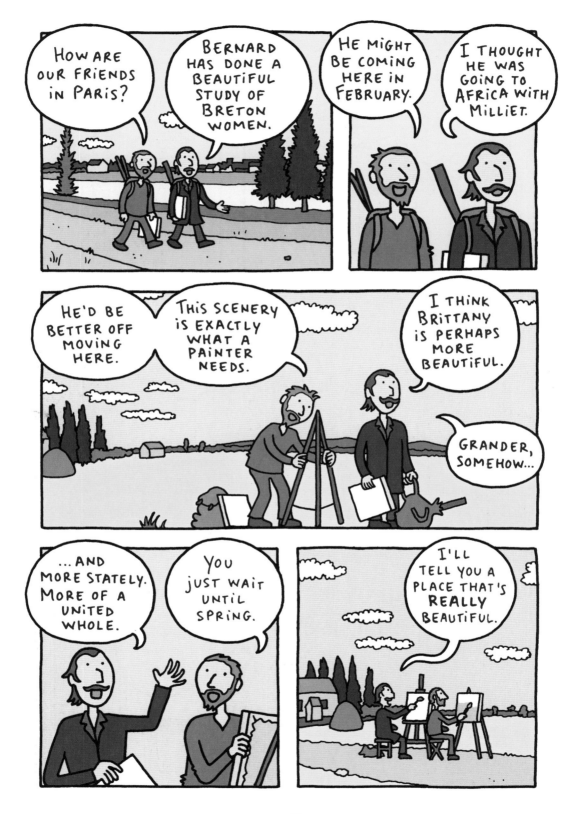

As you learned from my telegram, Gauguin arrived in good health. For a time I had the slight feeling that I was going to be ill, but Gauguin's arrival has so taken my mind off it that I am sure it will pass. I do not yet know his opinion of my work in general, but there are already a few studies that he thinks are really good.

I have done two canvases of falling leaves this week. At the moment Gauguin is working on some women in a vineyard, entirely from memory. Very fine and very strange. Watching him work is absolutely fascinating.

The house is going very, very well and is becoming a home fit for artists. In the evening, especially with the gaslight, I like the look of the studio very much.

He and I are managing better now on 150 francs a month each than I was with 250 for myself. So please do not be concerned about us. I shall send you all of my work, as usual, along with one painting a month by Gauguin.

My dear Theo,

Winter has come and I am most glad that I am not alone. Gauguin is encouraging me to work from memory. He is a very great artist and an excellent friend. You cannot imagine how happy I am to have such good company.

We talk a lot about Delacroix, Rembrandt, etc. and it will not surprise you that our conversations are often about the marvellous subject of an association of artists. Our discussions are absolutely electric. We sometimes emerge with exhausted minds, like discharged batteries.

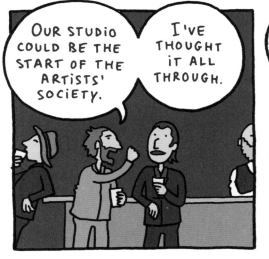

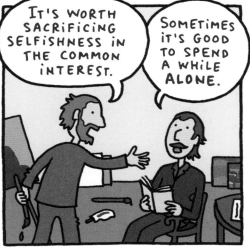

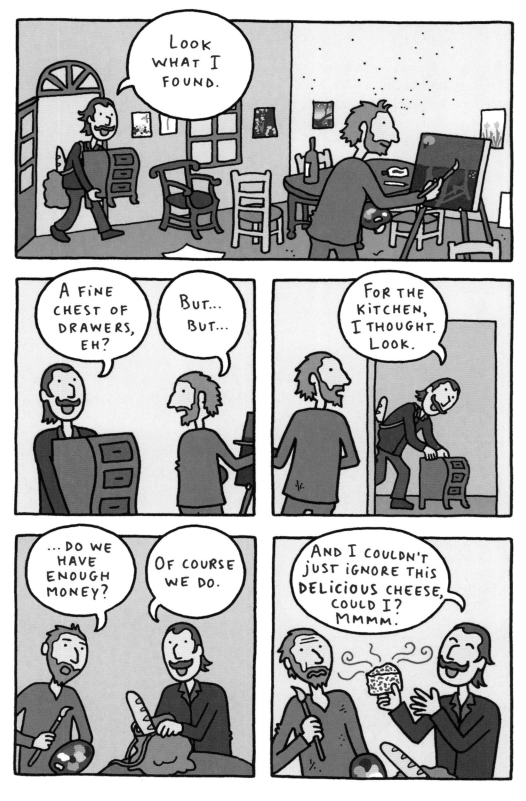

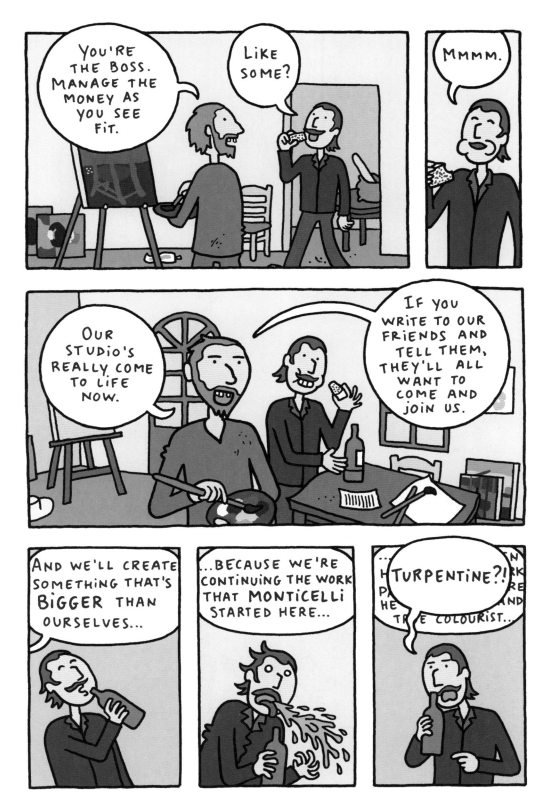

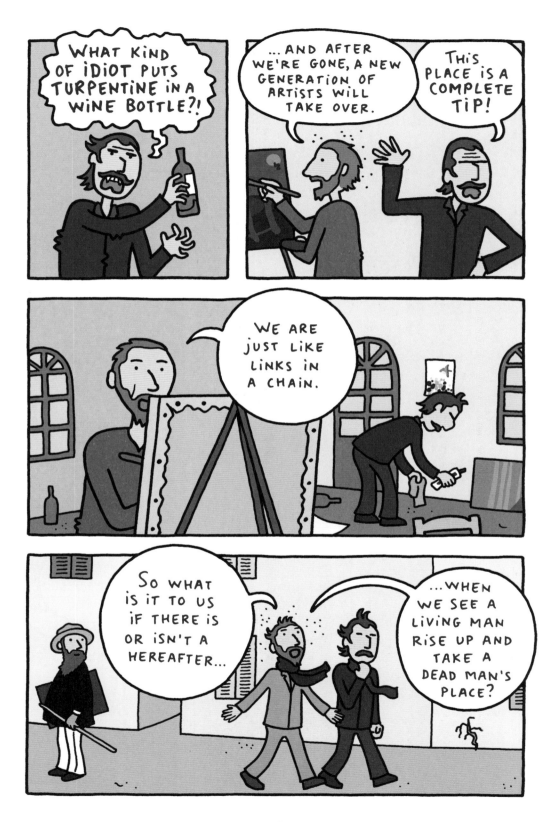

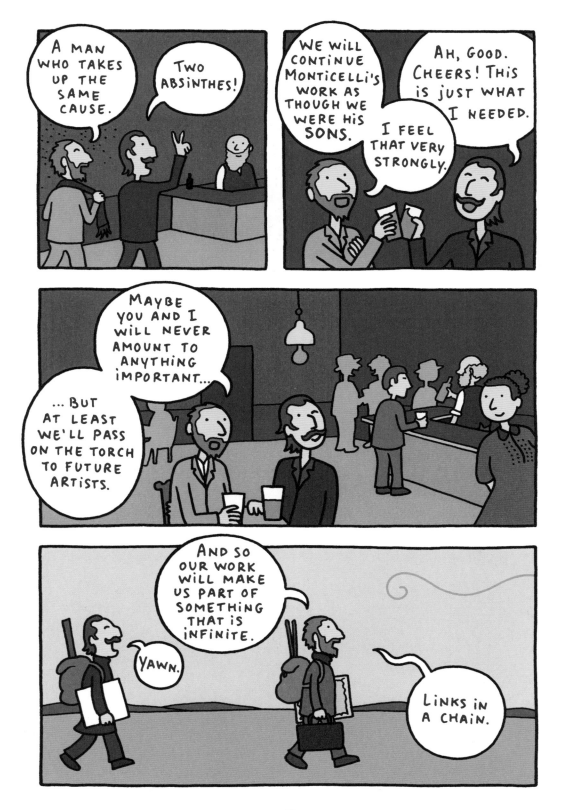

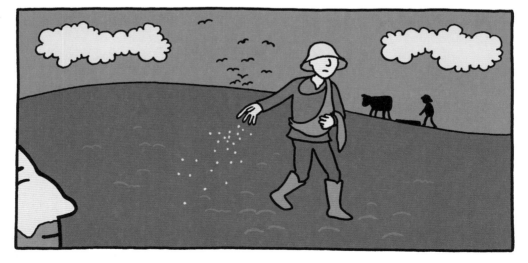

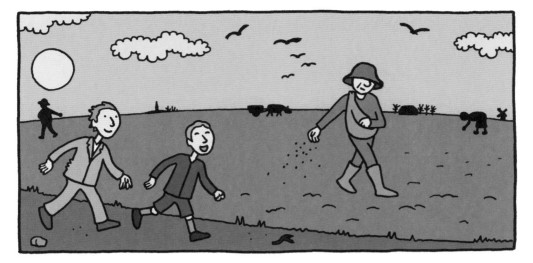

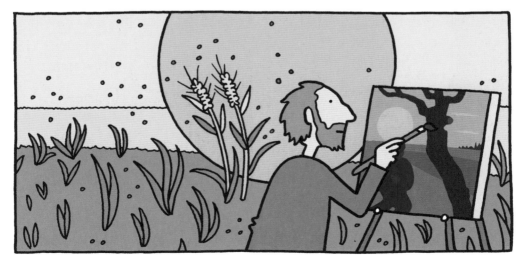

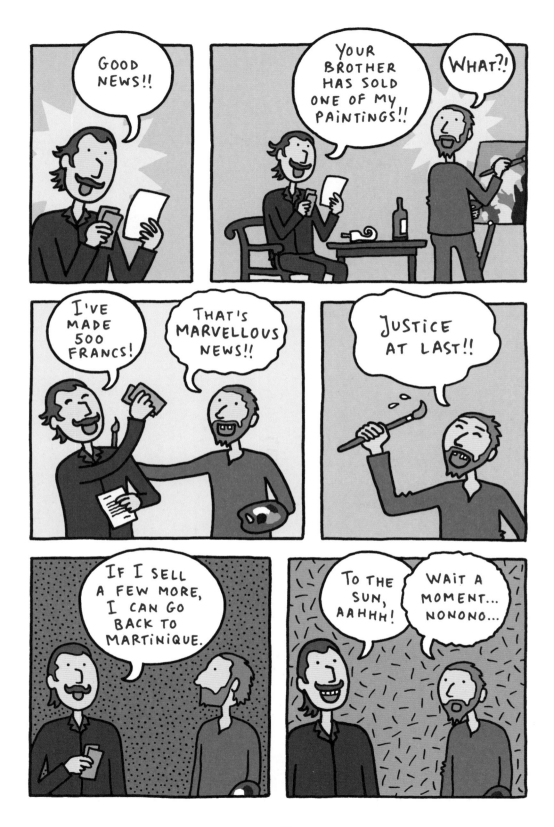

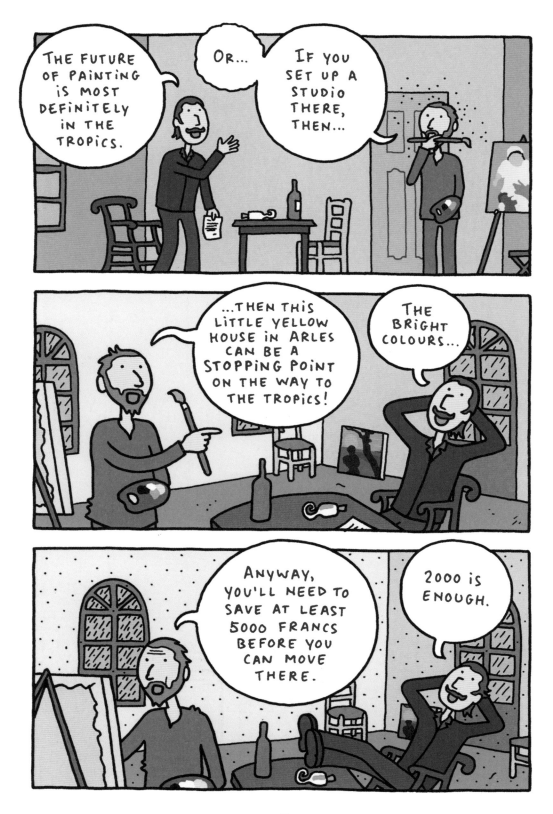

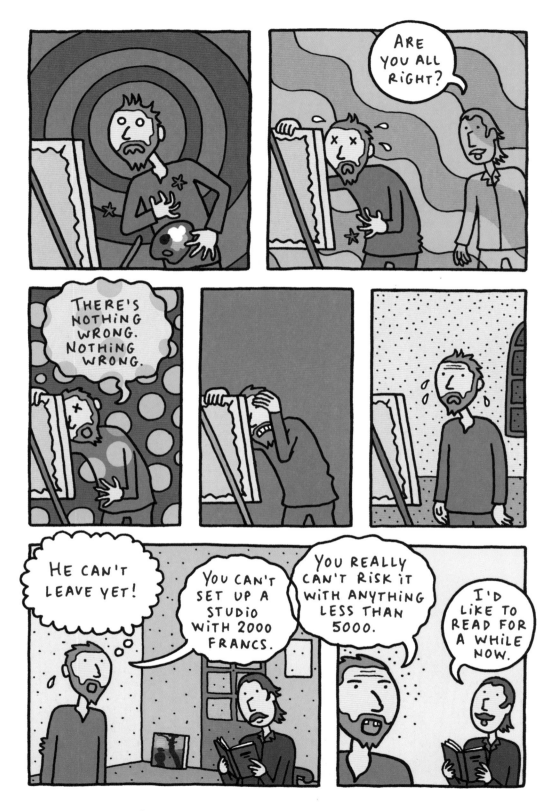

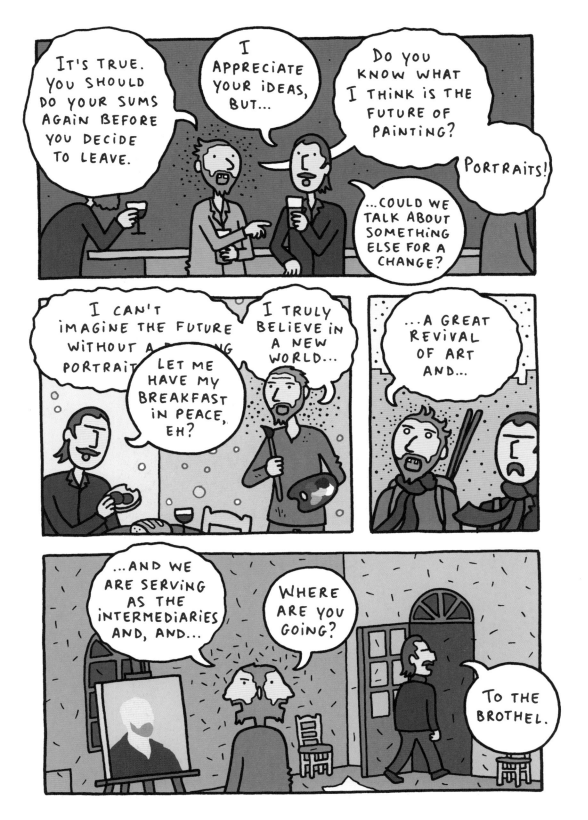

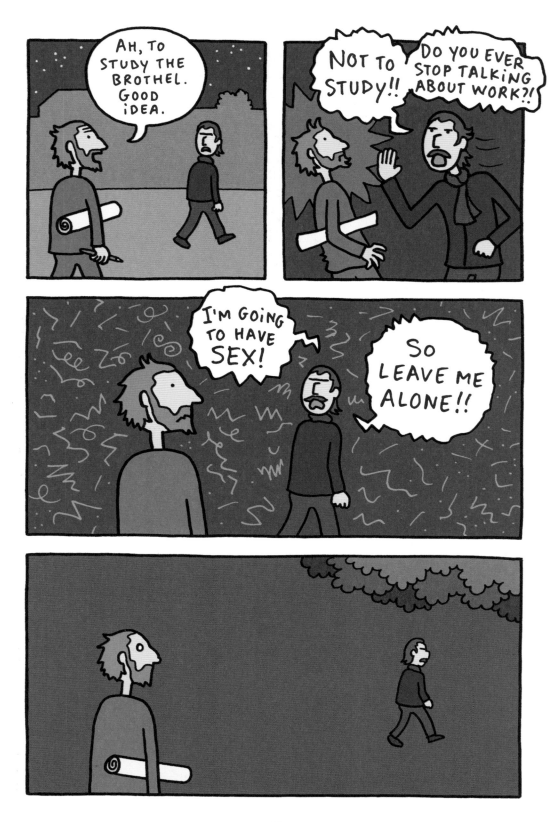

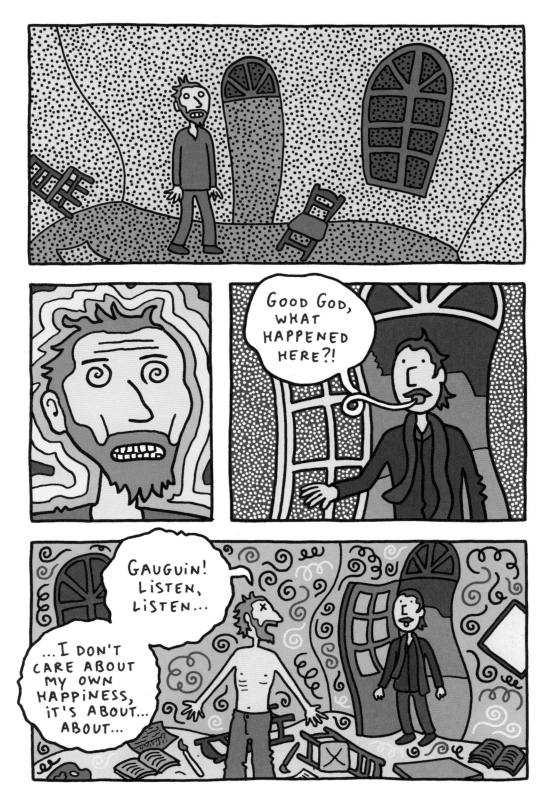

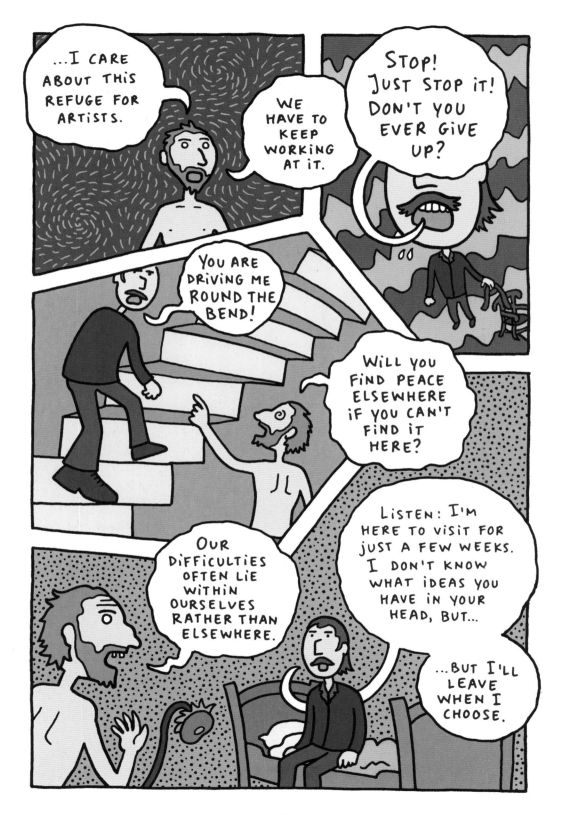

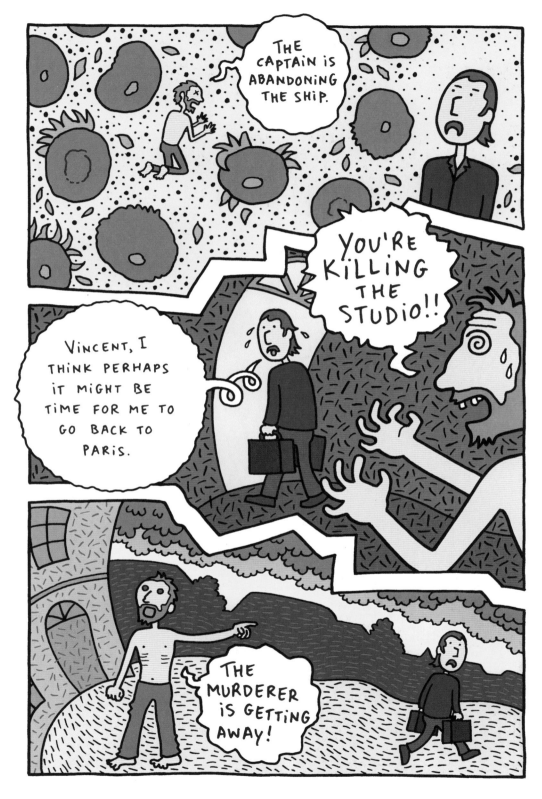

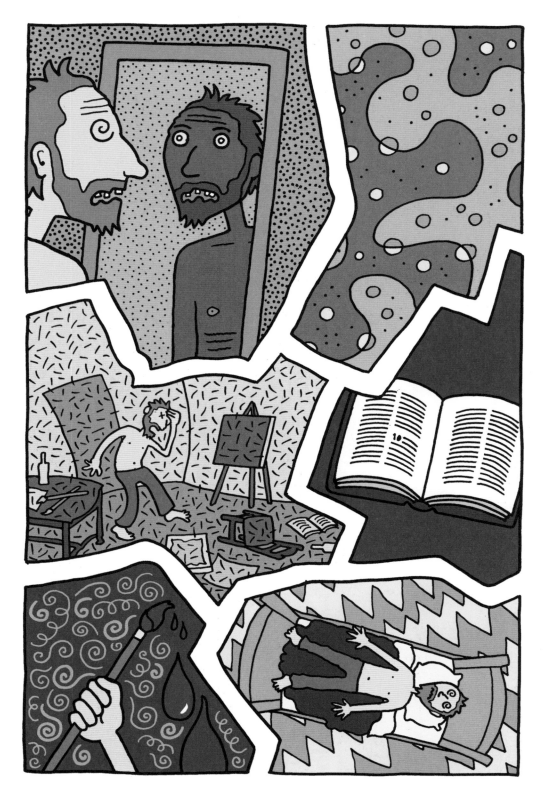

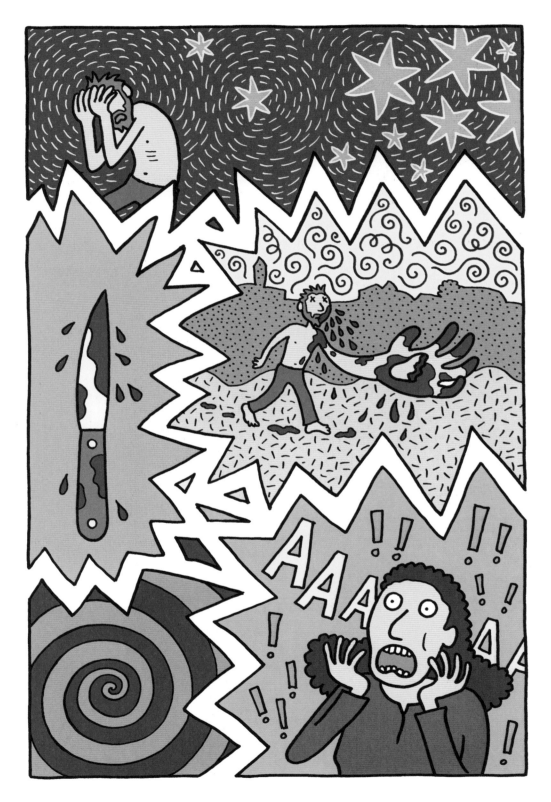

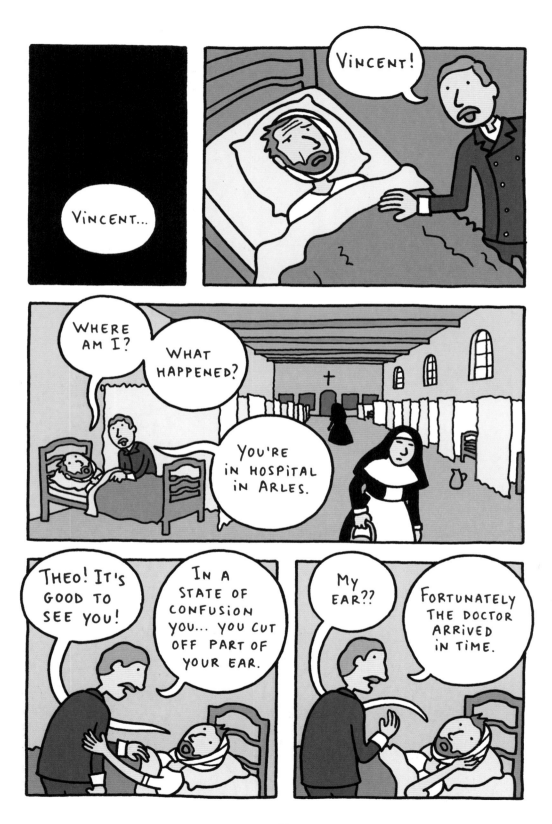

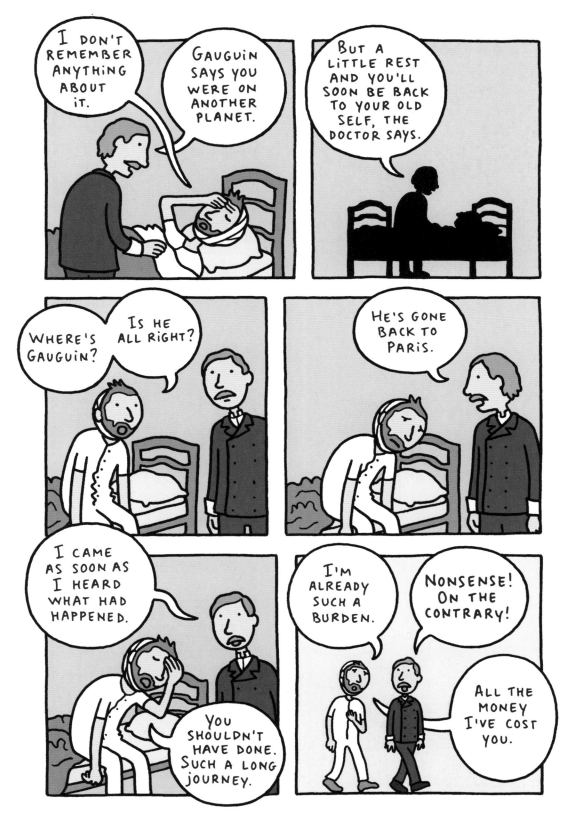

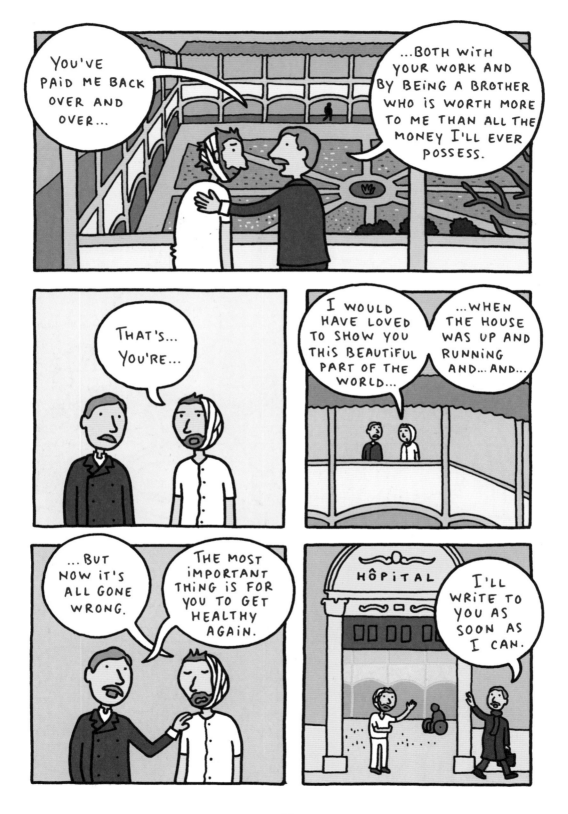

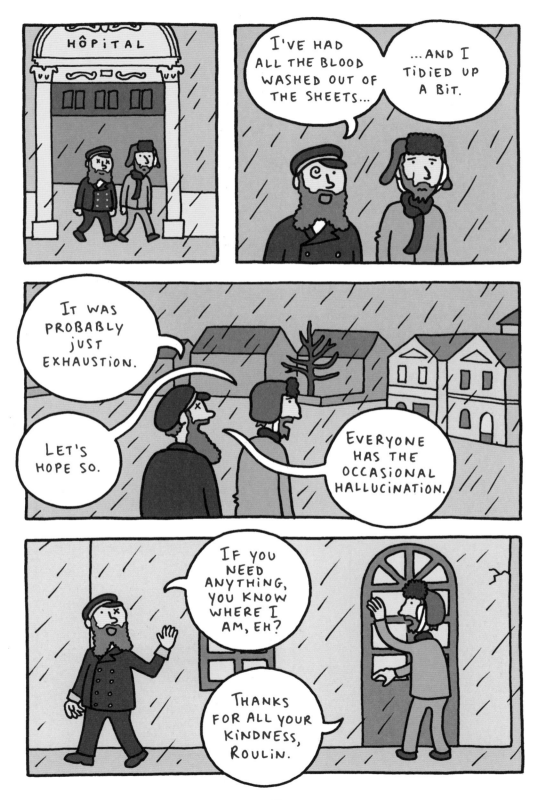

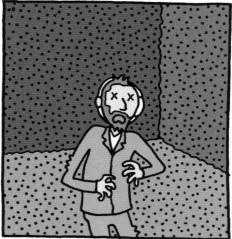

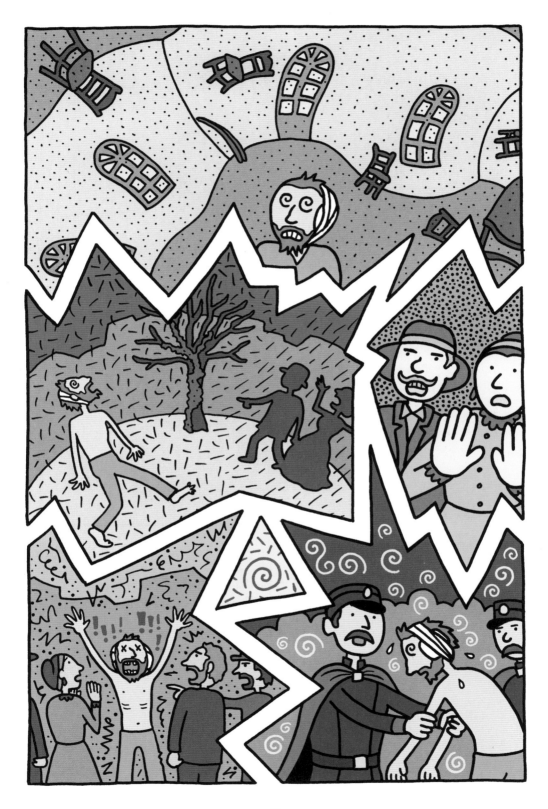

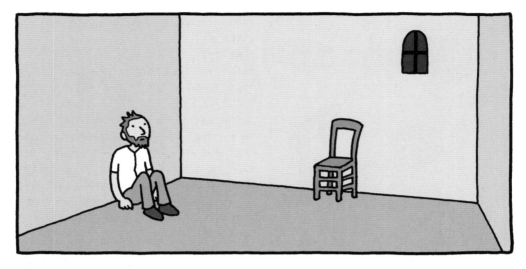

THE PAST FEW WEEKS HAVE BEEN VERY STRANGE. I HAVE TO A LARGE EXTENT LOST THE MEMORY OF THOSE DAYS, AND I CANNOT RECONSTRUCT ANYTHING. NOW I HAVE BEEN LOCKED UP IN AN ISOLATION CELL FOR DAYS. I HAVE TERRIBLE FITS OF ANXIETY AT TIMES AND THEN A FEELING OF EMPTINESS AND FATIGUE IN THE MIND. BUT THERE ARE ALSO MANY MOMENTS WHEN I FEEL COMPLETELY NORMAL, SO DO NOT BE CONCERNED ABOUT ME. AS FAR AS I CAN TELL, I AM NOT TRULY INSANE.

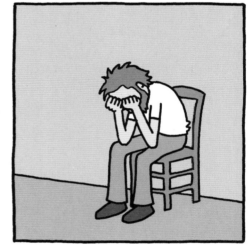

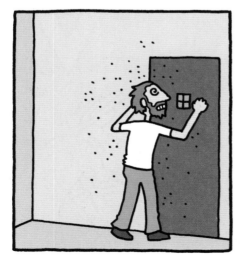

SOME LOCAL PEOPLE HAVE ADDRESSED A PETITION WITH MORE THAN 80 SIGNATURES TO THE MAYOR, DESCRIBING ME AS A MAN NOT FIT TO LIVE AT LIBERTY, OR SOMETHING ALONG THOSE LINES. THE POLICE HAVE LOCKED UP MY HOUSE. YOU CAN IMAGINE HOW MUCH OF A BLOW IT IS THAT SO MANY PEOPLE HERE HAVE BEEN COWARDLY ENOUGH TO BAND TOGETHER AGAINST ONE MAN, AND A SICK ONE AT THAT. I AM BADLY SHAKEN, BUT IF I BECOME TOO ANGRY, I WILL RUN THE RISK OF SUFFERING ANOTHER ATTACK.

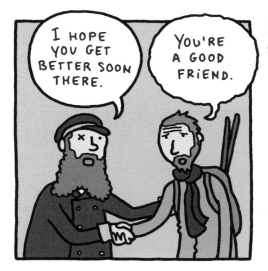

Now that I am a little calmer, I realise what trouble I have caused. My mental health may well have deteriorated for good, so it is best if I go straight to an asylum. For the moment I feel decidedly incapable of taking a new studio and living there alone. I wish to go to the mental hospital at Saint-Rémy that the doctor told me about. I think that will be for the best, and I see no other way.

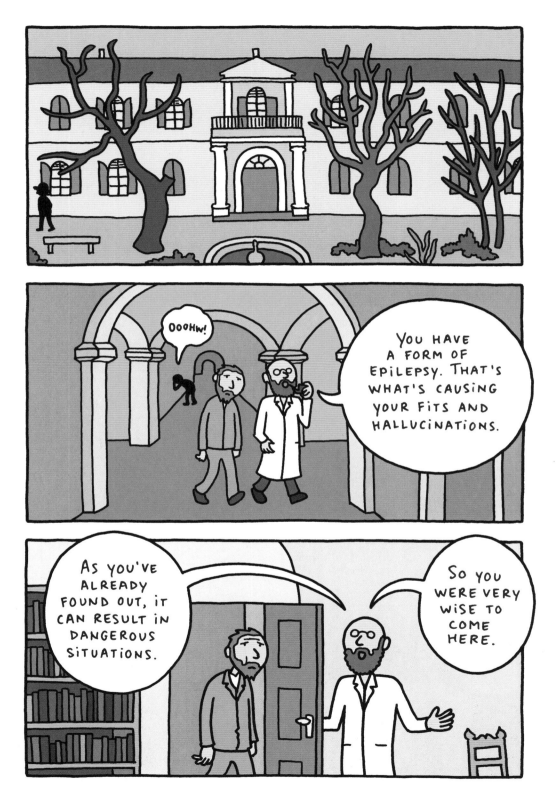

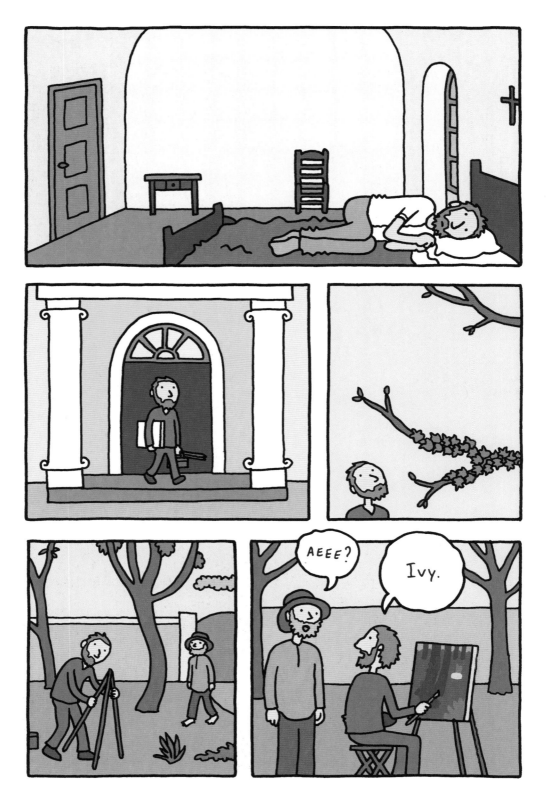

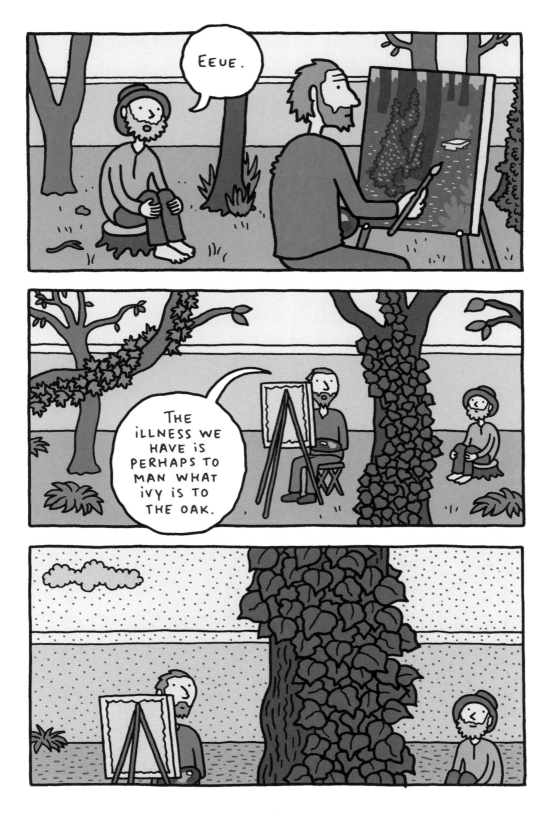

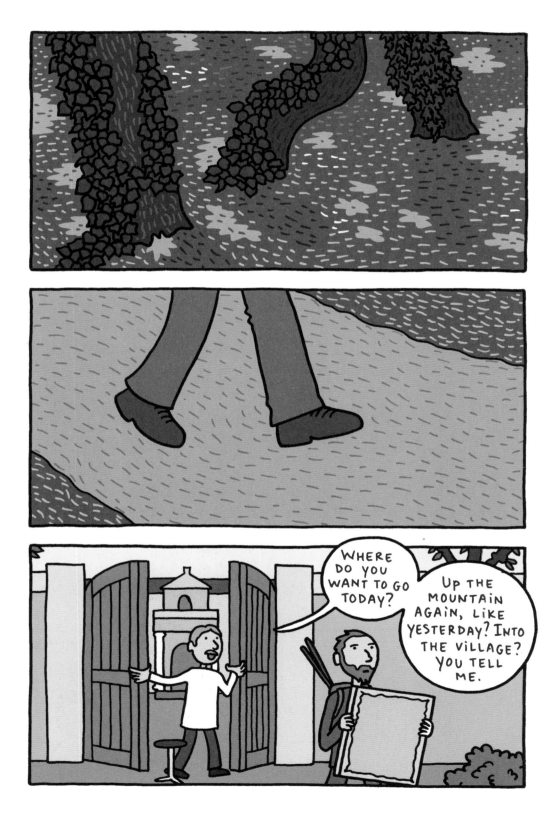

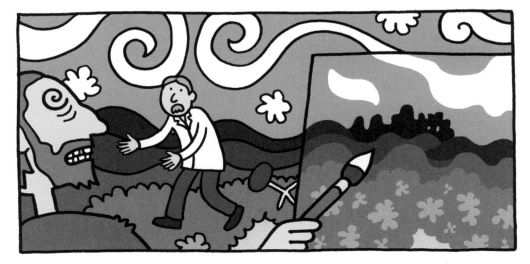

My dear Theo,

I am sure you understand how very deeply distressed I am that the attacks have recurred when I was already beginning to believe that they might not. For many days I have been absolutely distraught, as in Arles, if not worse. But we are all mortal and subject to all possible illnesses, so it is only fair that I should receive my share.

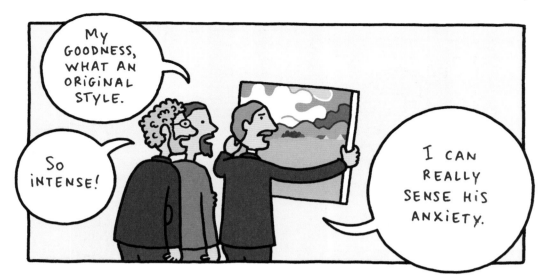

My dear Vincent,

Your latest paintings have given me a great deal to think about as regards your state of mind. All of them have a power of colour which you have not attained before, which in itself is a rare quality, but you have gone further. How hard your mind must have worked and how you have endangered yourself to that extreme point where disorientation is inevitable. For that reason, my dear brother, I am rather concerned, because you must not put yourself at risk before your complete recovery. Even if you give only a simple account of what you see, there are sufficient good qualities for your canvases to last. You have already produced so much beautiful work!

Do not lose courage.
I think of you often.

Theo

My dear Theo,

Since I last wrote to you, I have been feeling better. Work distracts me and might possibly be the best remedy.

The weather has been splendid for a very long time, but I have not left my room for two months. I am not sure why. I work almost without stopping from morning to night.

It is only while working at the easel that I feel alive.

I am painting to console myself, for my own pleasure.

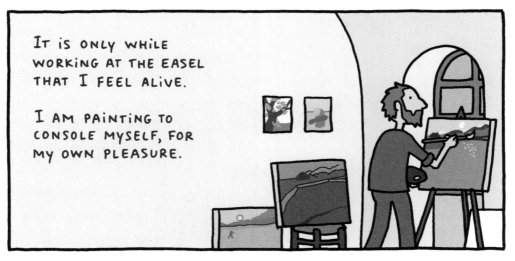

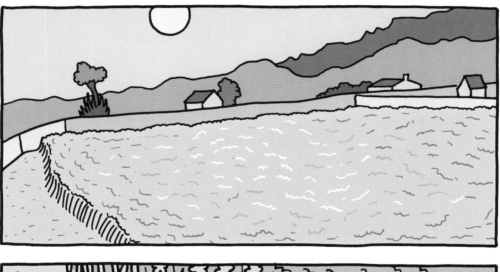

WHEN I THINK OF ALL THE THINGS WHOSE REASON I DO NOT UNDERSTAND, I JUST GAZE UPON THE WHEAT FIELDS. THEIR STORY IS OURS, FOR ARE WE NOT OURSELVES WHEAT TO A CONSIDERABLE EXTENT? WE MUST SUBMIT TO THE FACT THAT WE GROW LIKE PLANTS, POWERLESS TO MOVE AS OUR IMAGINATION SOMETIMES DESIRES, AND THAT WE ARE REAPED WHEN WE ARE RIPE.

I FEEL SO STRONGLY THAT THE STORY OF HUMANKIND IS LIKE THE STORY OF WHEAT. IF ONE IS NOT SOWN IN THE EARTH TO GERMINATE THERE, WHAT DOES IT MATTER? ONE IS STILL MILLED TO BECOME BREAD. THE DIFFERENCE BETWEEN FORTUNE AND ADVERSITY, GOOD AND EVIL, BEAUTIFUL AND UGLY... IT IS ALL SO RELATIVE.

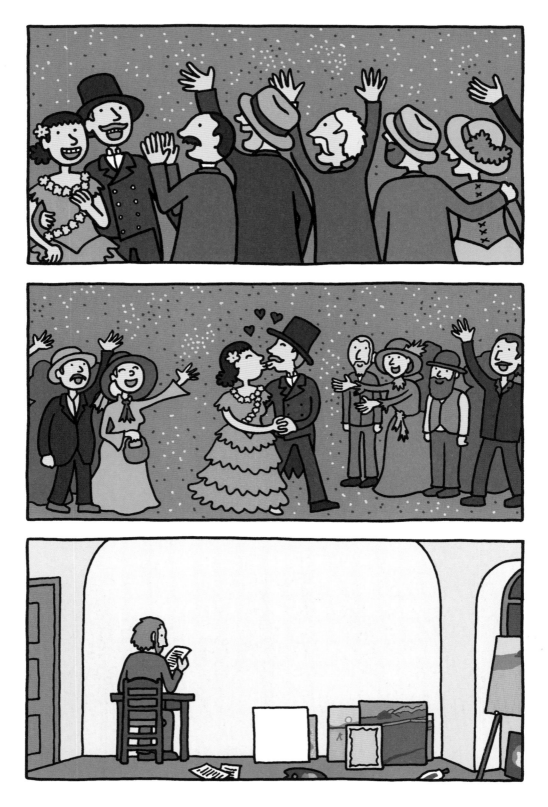

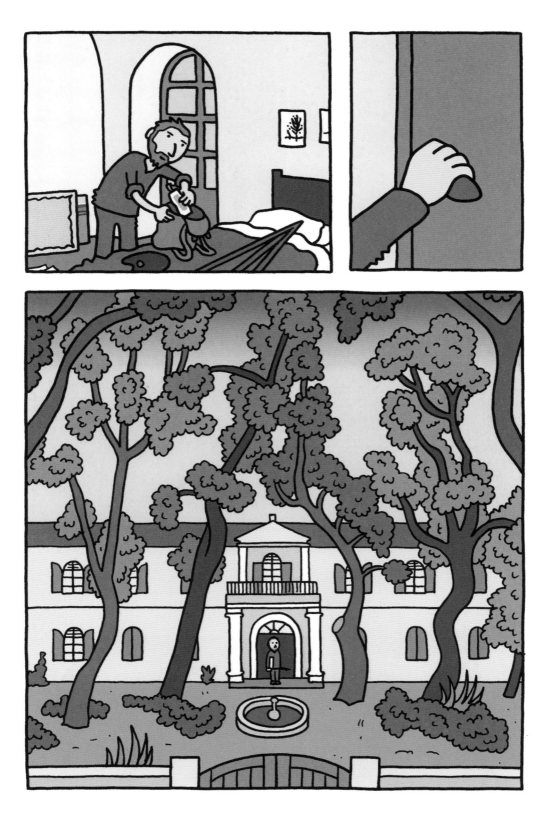

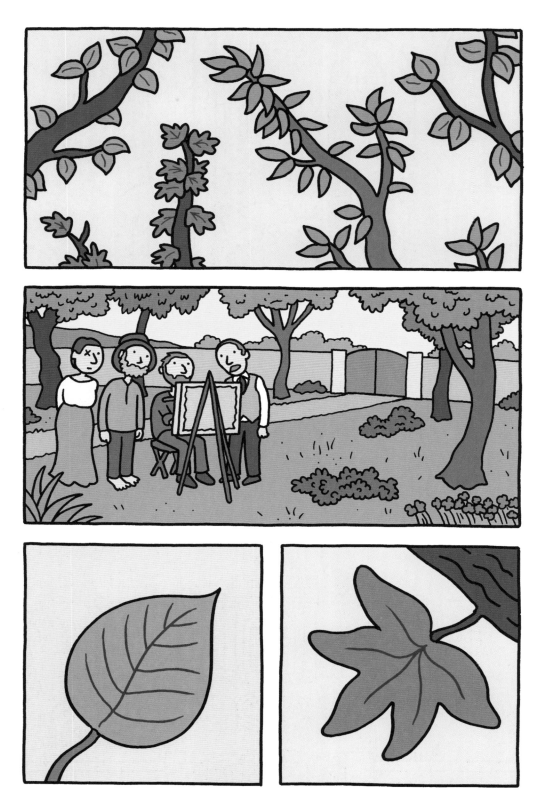

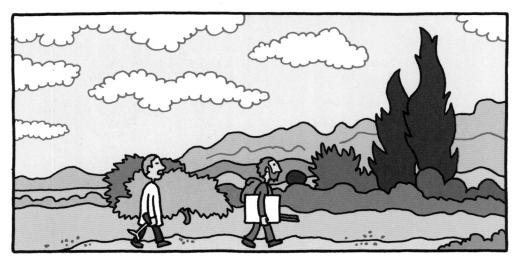

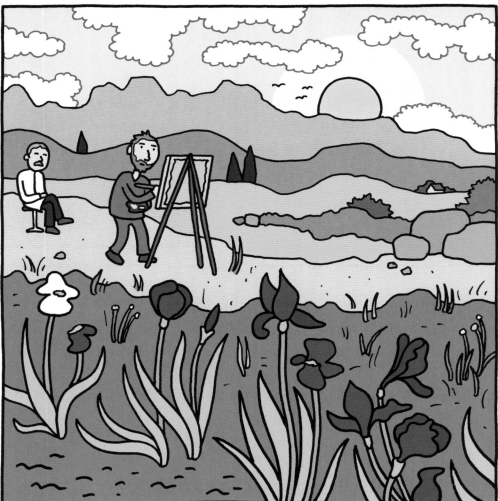

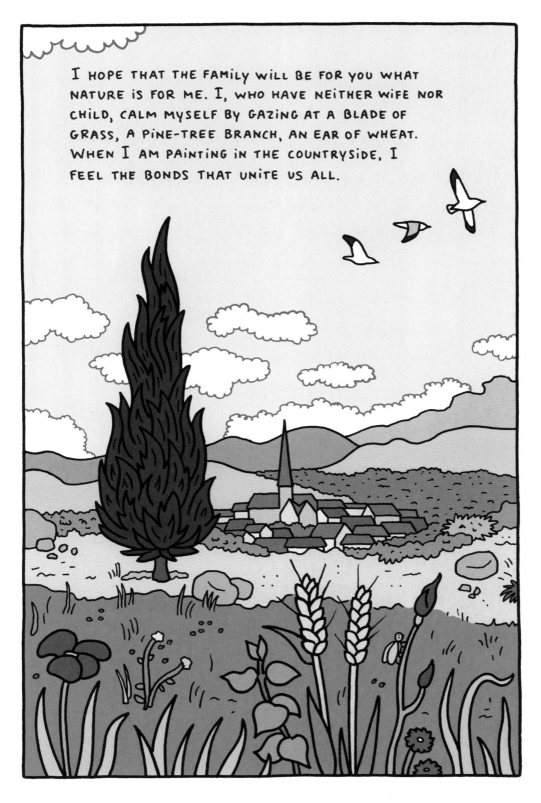

I HOPE THAT THE FAMILY WILL BE FOR YOU WHAT
NATURE IS FOR ME. I, WHO HAVE NEITHER WIFE NOR
CHILD, CALM MYSELF BY GAZING AT A BLADE OF
GRASS, A PINE-TREE BRANCH, AN EAR OF WHEAT.
WHEN I AM PAINTING IN THE COUNTRYSIDE, I
FEEL THE BONDS THAT UNITE US ALL.

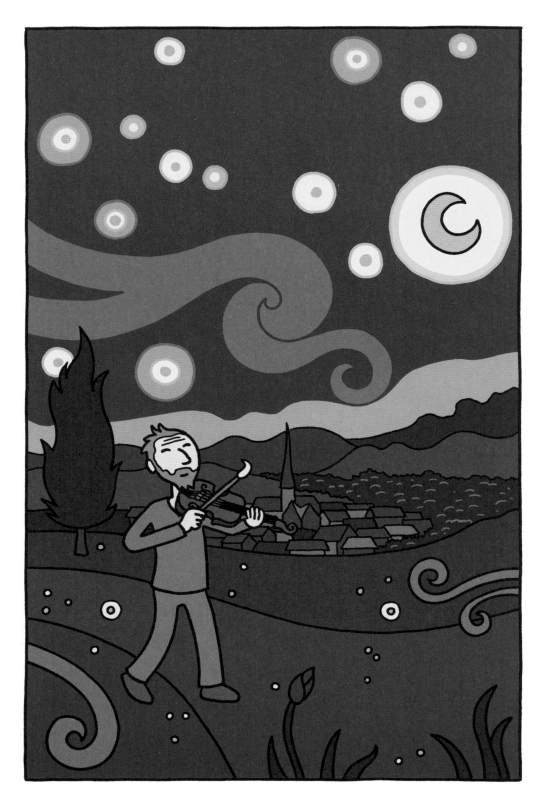

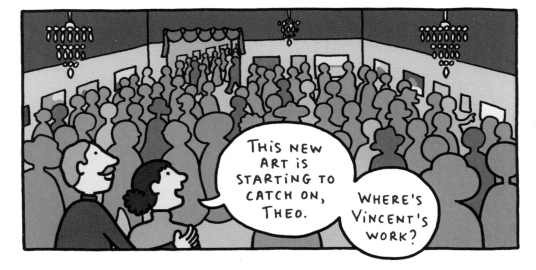

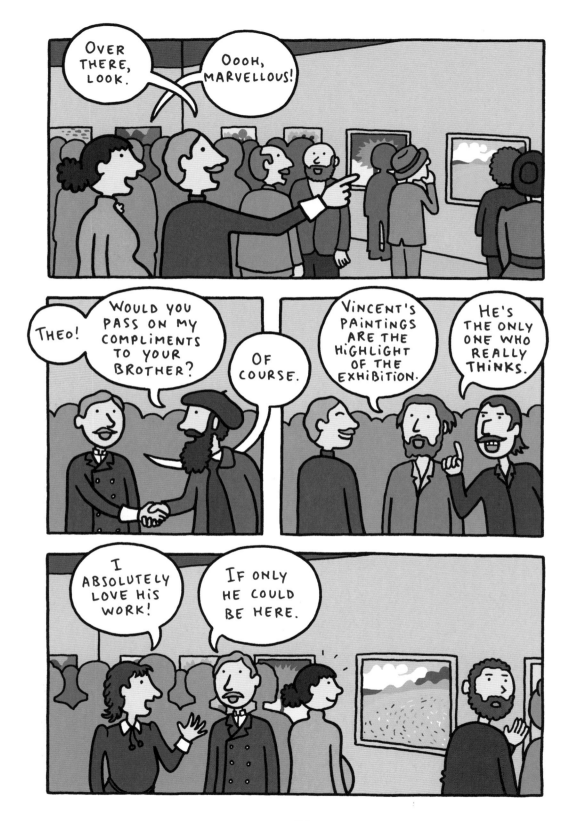

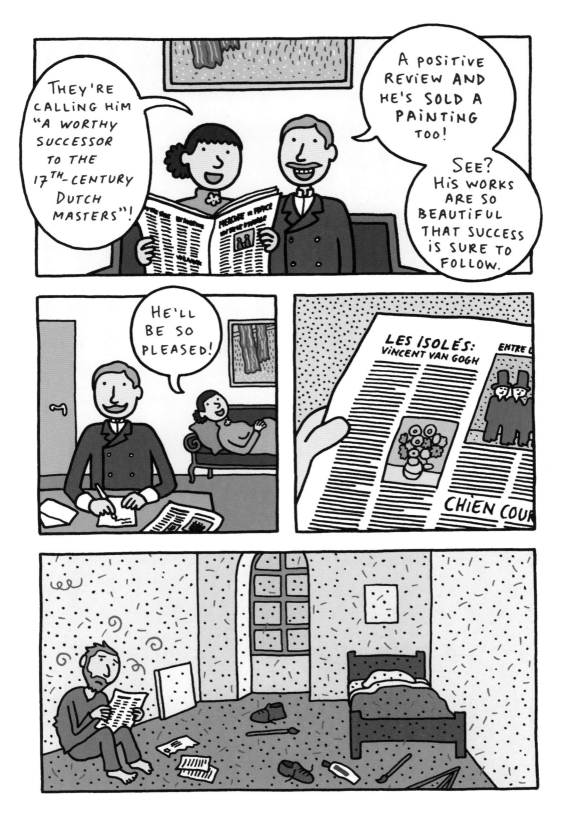

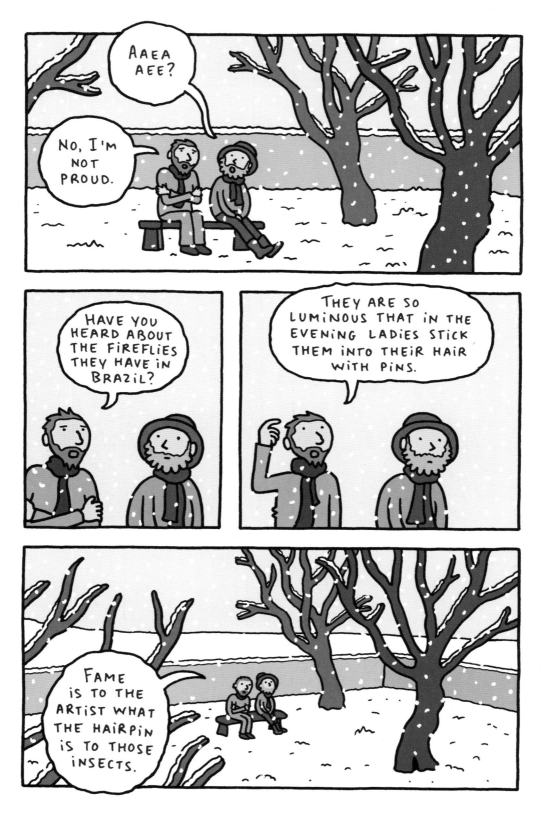

My DEAR VINCENT,
Jo HAS GIVEN BIRTH TO A
BEAUTIFUL BABY BOY. HE HAS
BLUE EYES AND FAT CHEEKS.
WE HAVE NAMED HIM
AFTER YOU AND I AM
MAKING THE WISH
THAT HE MAY BE AS
DETERMINED AND
AS COURAGEOUS
AS YOU ARE.

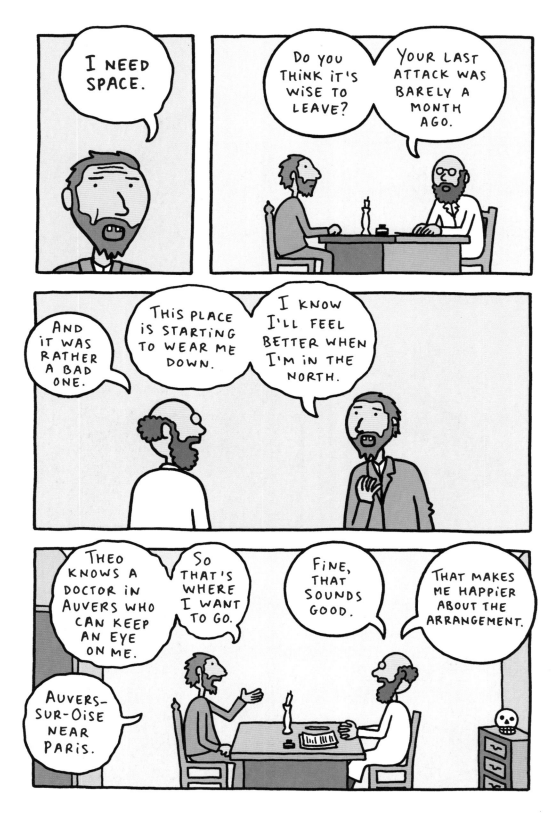

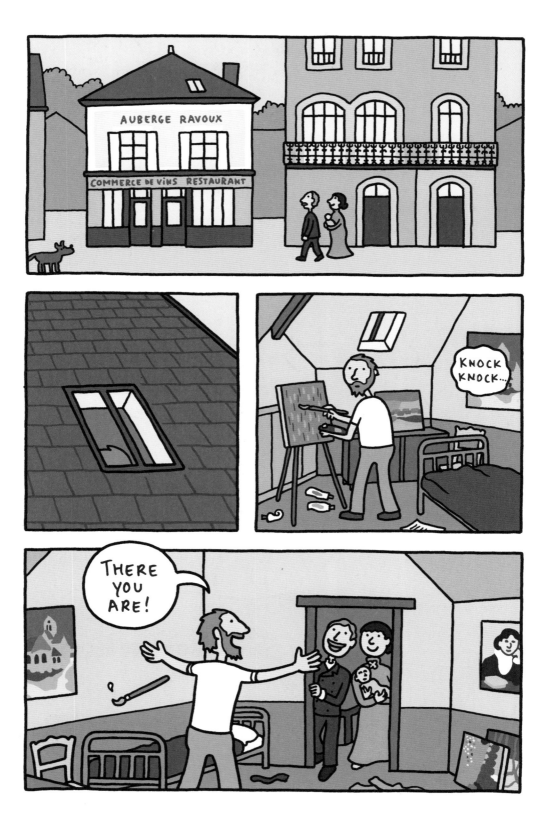

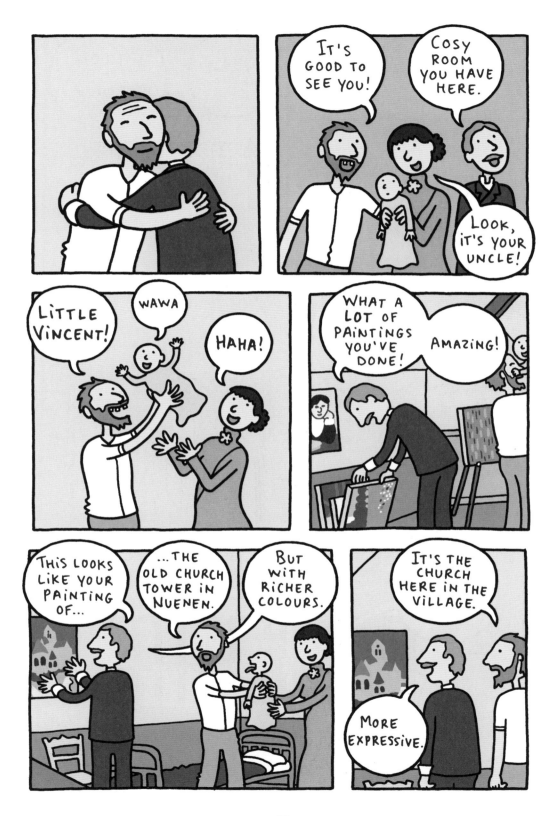

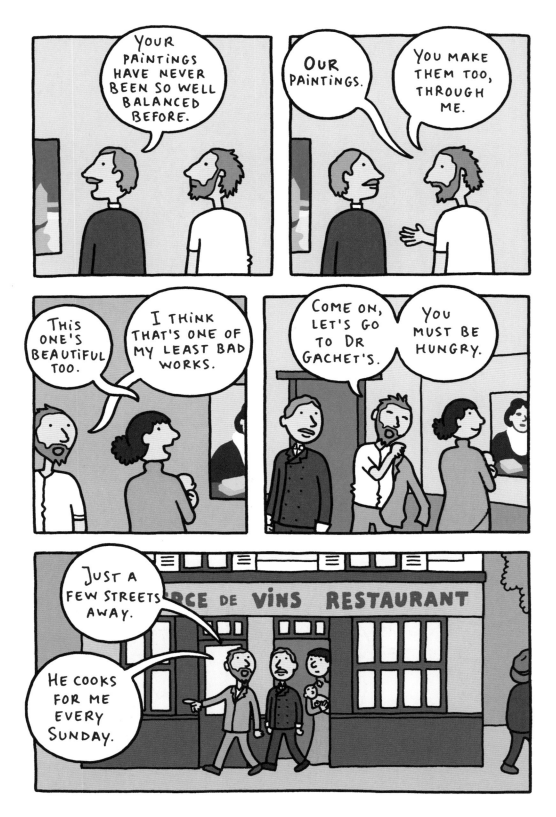

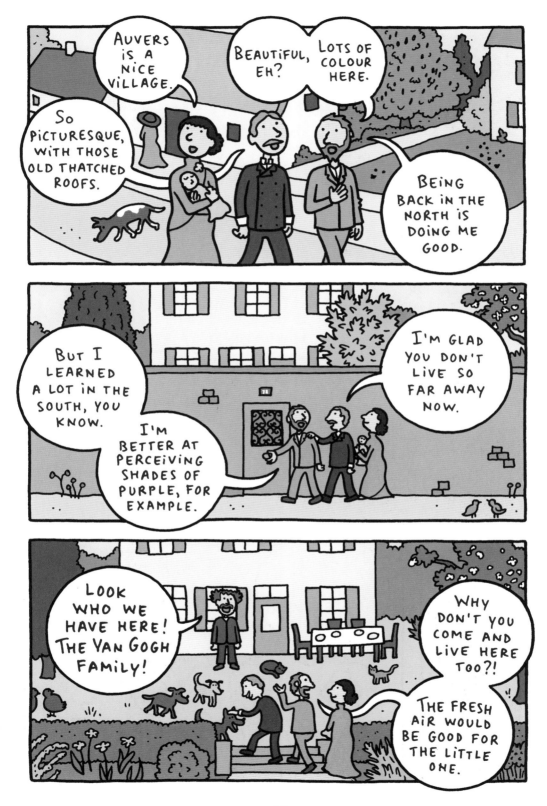

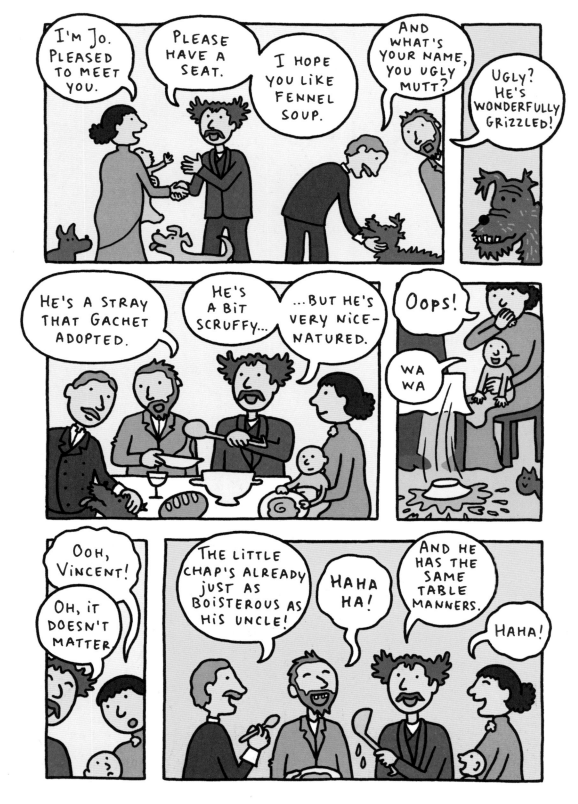

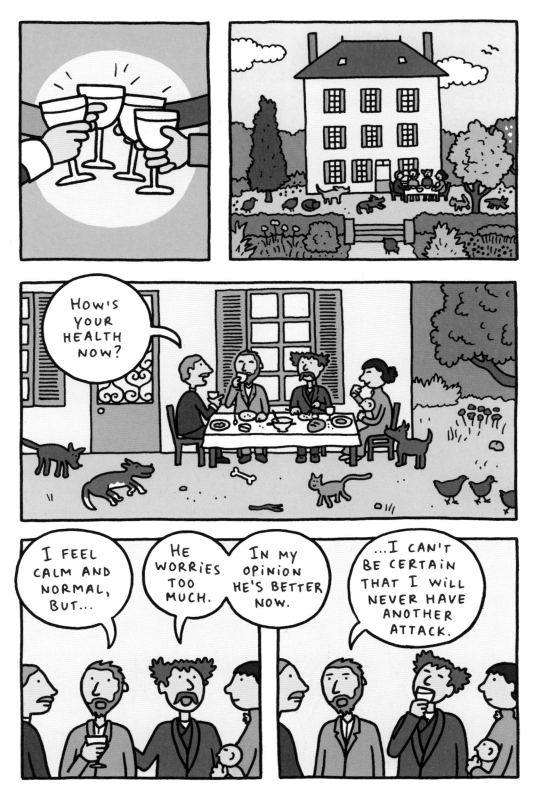

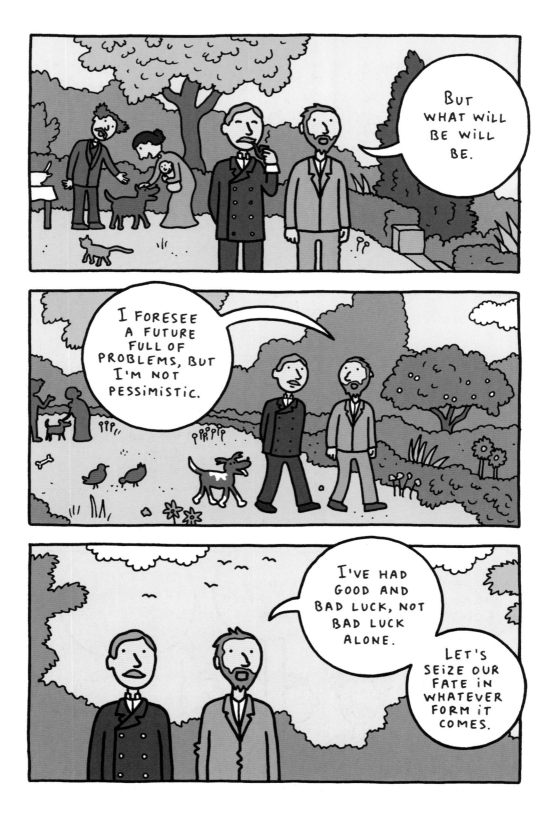

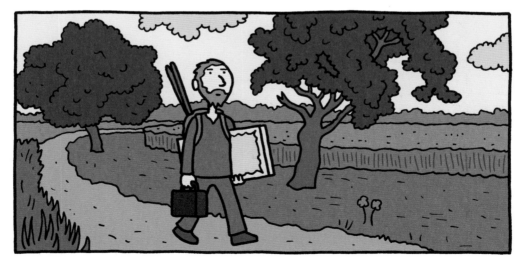

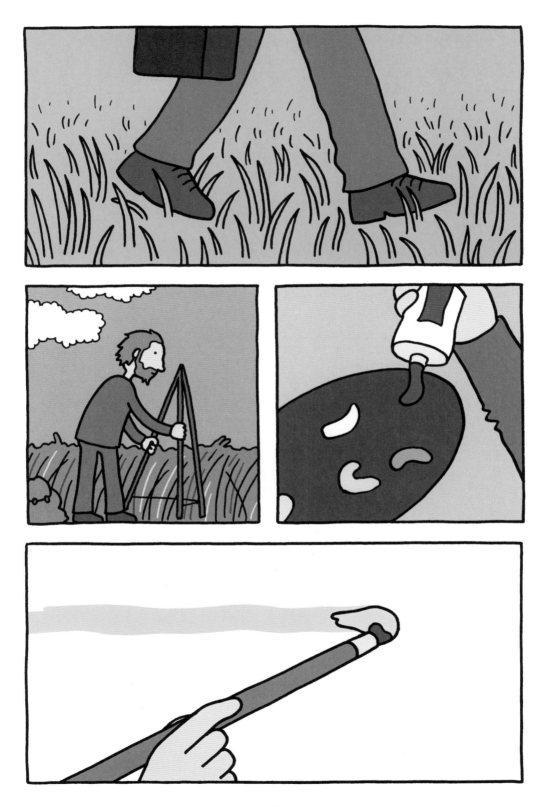

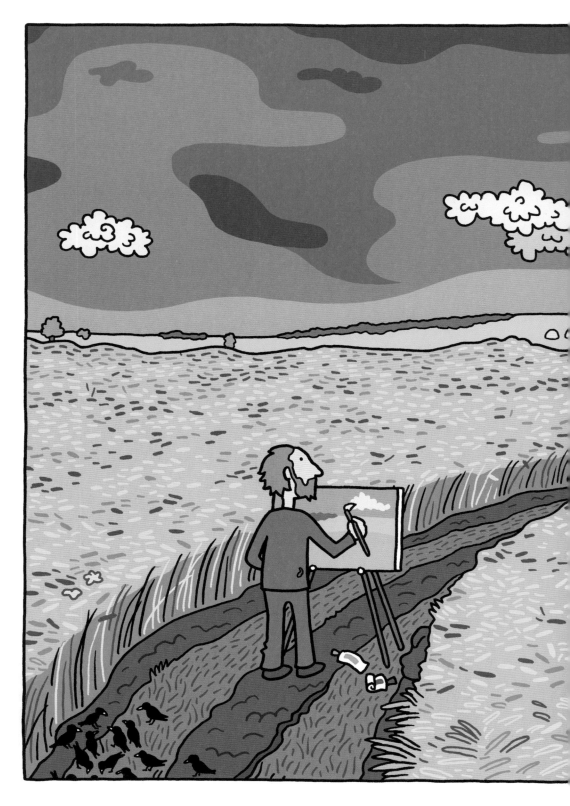

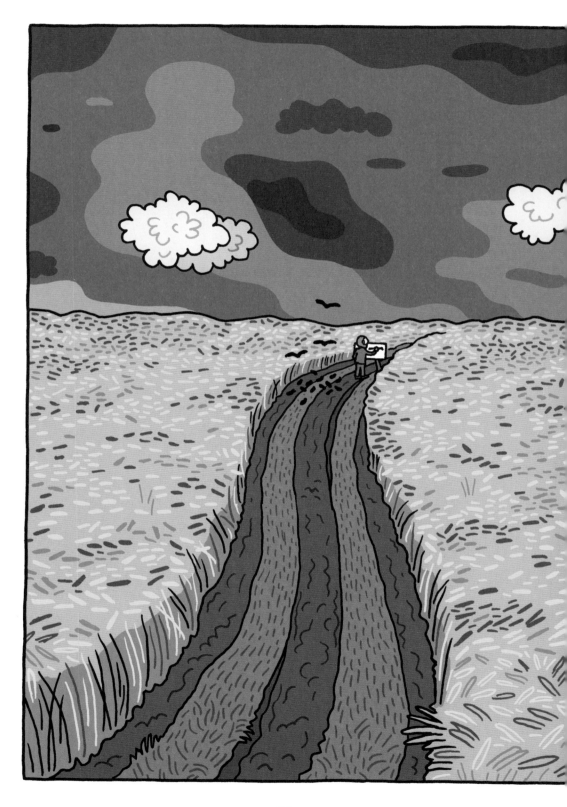

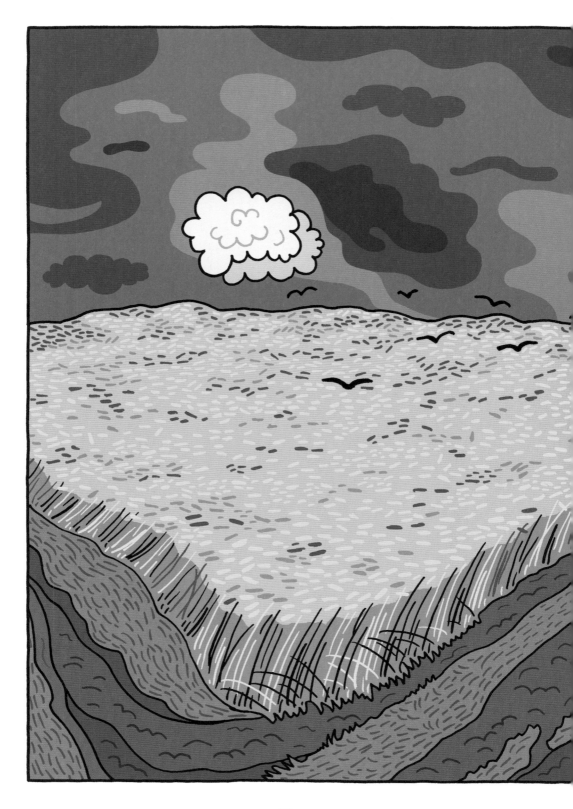

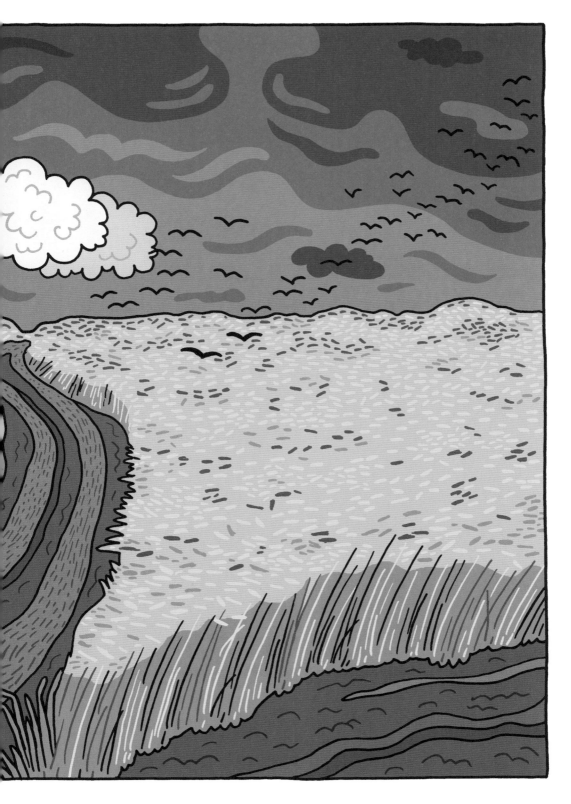

ici REPOSE
**VINCENT
VAN GOGH**
1853 – 1890

ici REPOSE
**THEODORE
VAN GOGH**
1857 – 1891

This edition published in the UK in 2014 and in the US in 2015
by SelfMadeHero
139 Pancras Road
London NW1 1UN
www.selfmadehero.com

Vincent is a joint initiative by the Van Gogh Museum Amsterdam, the Mondriaan Fund and
Nijgh & Van Ditmar publishers.

Written and Illustrated by: Barbara Stok
Colouring & cover design by: Ricky van Duuren
Translated by: Laura Watkinson

Sales & Marketing Manager: Sam Humphrey
Publishing Assistant: Guillaume Rater
Publishing Director: Emma Hayley
Press Officer: Paul Smith
With thanks to: Jane Laporte and Kate McLauchlan

This book was published with the support of the Dutch Foundation for Literature

A CIP record for this book is available from the British Library

ISBN: 978-1-906838-79-9

10 9 8 7 6 5 4 3 2

Printed and bound in Slovenia

Also available in the **ART MASTERS** series:

PABLO
by Julie Birmant and Clément Oubrerie

ISBN 978-1-906838-94-2
Paperback, 344 pages
RRP: UK £16.99 US $27.50 CAN $31.50
Available in all good bookshops